Irvin Tepper

When Cups Speak

Life With the Cup: A 25-Year Survey

Irvin Tepper

When Cups Speak

Life With the Cup: A 25-Year Survey

Jo Farb Hernández

With additional contributions by:

Edmund Burke Feldman
Marc Freidus
James Harithas
Janet Koplos
Robert W. Milnes
David A. Ross
Paul Schimmel
Armando Suárez-Cobián

Natalie and James Thompson Art Gallery
School of Art and Design
San José State University
San José, California

San José State
UNIVERSITY

Irvin Tepper
When Cups Speak
Life With the Cup: A 25-Year Survey

Natalie and James Thompson Art Gallery
School of Art and Design
San José State University
San José, California

Published by the Natalie and James Thompson Art Gallery, School of Art and Design, San José State University, One Washington Square, San José, CA 95192–0089 on the occasion of the Irvin Tepper survey exhibition, *When Cups Speak: Life with the Cup.*

Support for this project has been provided by the Tepper Family Foundation with additional funds provided by a California State University Research Funds Award; Kenneth A. Cowin; Dan and Jeanne Fauci; and Dotty and Arnold Tepper.

Graphic Design and Production: Cristina Hernández-Villalón
Printer: Oceanic Graphic Printing
Printed in China

Photography: Unless otherwise indicated, all photographs © the artist.
Reproduction of Roy Lichtenstein's *Ceramic Sculpture 3* is courtesy the Estate of Roy Lichtenstein.
Reproduction of *Third Cup of Coffee* is courtesy the Arkansas Arts Center.
Reproduction of *Roger* is courtesy the Fine Arts Museum of San Francisco/M.H. de Young Memorial Museum.
Reproduction of *Betty's Cup* and *Cup and Saucer* are courtesy the Los Angeles County Museum of Art.
Reproduction of *A-6* is courtesy the Mint Museum of Craft and Design.
Reproduction of *You Know Dorothy, Don't You?* is courtesy the Museum of Contemporary Art, Los Angeles.
Reproduction of *Big Ear or Big Mouth* is courtesy the Orange County Museum of Art.

Library of Congress Cataloging-in-Publication Data
Hernandez, Jo Farb.
Irvin Tepper, when cups speak : life with the cup : a 25-year survey / Jo Farb Hernandez.
 p. cm.
Includes bibliographical references.
1. Tepper, Irvin--Exhibitions. 2. Drinking cups in art--Exhibitions. I. Title. II. Title: Irvin Tepper.
N6537.T4523 A4 2002
709'.2--dc21
 2002007195

ISBN 0-9721984-0-7

TABLE OF CONTENTS

Preface 5

Robert W. Milnes
Director
School of Art and Design
San José State University
San José, CA

Introduction and Acknowledgments 7

Jo Farb Hernández
Director, Natalie and James Thompson Art Gallery
School of Art and Design
San José State University
San Josć, CA

Artist's Statement 9

Irvin Tepper

Life with the Cup: An Interview with Irvin Tepper 11

Jo Farb Hernández
Director, Natalie and James Thompson Art Gallery
School of Art and Design
San José State University

Animism 37

Paul Schimmel
Chief Curator, Museum of Contemporary Art
Los Angeles, CA

Third Cup of Coffee 77

Dr. Edmund Burke Feldman
Alumni Foundation Distinguished Professor of Art
School of Art
University of Georgia
Athens, GA

Sacred Vessels 83

James Harithas
Director, Art Car and ACME Museums
Houston, TX

Burnt 87

David A. Ross
Brooklyn, New York

A Cup of A Photograph 97

Marc Freidus
Independent Curator
New York, NY

Forma, Luz y Posibilidad / Form, Light and Possibility 109

Armando Suárez-Cobián
Writer and Poet
New York, NY

Non-Standard: Irv Tepper's Oppositional Cups 115

Janet Koplos
Senior Editor
Art in America
New York, NY

Professional and Exhibition History 128

Lenders to the Exhibition 134

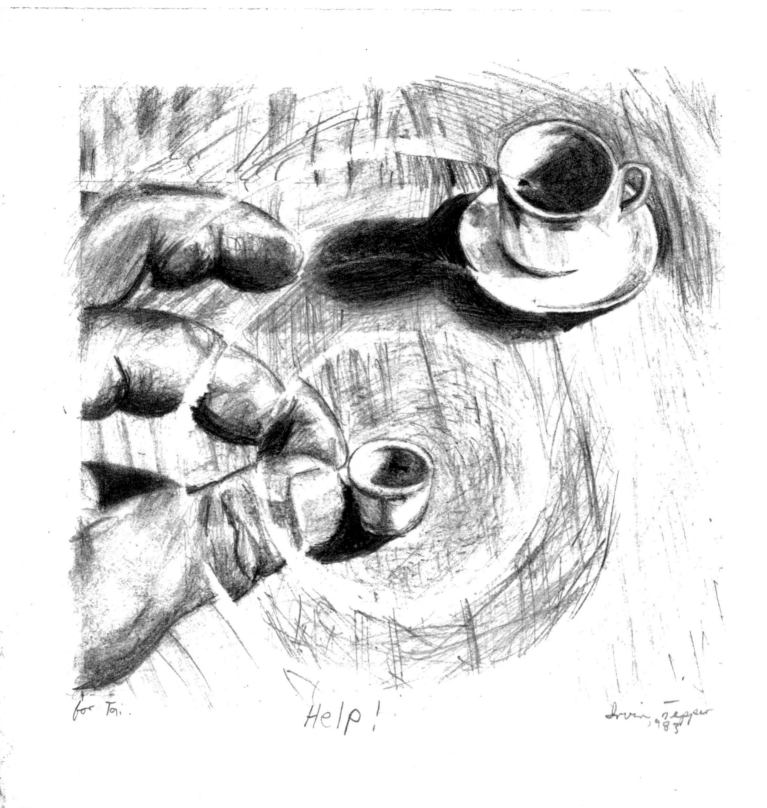

for Toi. Help! Irvin Tepper
 1983

PREFACE

Robert W. Milnes

Director
School of Art and Design
San José State University
San José, CA

I remember first seeing one of Irv Tepper's pieces, a wedge of lemon meringue pie complete with a large wave and plastic surfers, at the Manolides Gallery in Seattle sometime back around 1971. It knocked me out then, and it still resonates strongly with me. Irv Tepper was a legendary member of the art community in that city, and was also noted as part of a broader network of innovative artists nationally. Always interested in new approaches to artmaking while still rooted to the ceramic forms of his earlier pieces, Irv Tepper has since crossed boundaries of materials, content, and approach with his work. This exhibition offers an opportunity to view the expansion of one person's visions while it simultaneously affords us a view of the expansion of the art and design world over the past thirty years.

San José State University's School of Art and Design provides an appropriate first setting for this exhibition. Our School of Art and Design was initially formed in 1911, and we celebrated the twenty-fifth anniversary of the Bachelor of Fine Arts and Master of Fine Arts programs in 1999. With nearly 1700 majors enrolled in ten programming areas, the School is now one of the largest and most diverse programs of its type in the nation, with widely recognized programs in design fields including graphic, industrial, and interior design; pictorial and spatial arts disciplines including ceramics, glass, weaving/textiles, painting, printmaking, photography, sculpture, and performance art; digital media art, animation, and illustration. Interestingly and characteristically, Irv Tepper has been active in most of these!

This catalog is produced by the Natalie and James Thompson Art Gallery. Specifically focusing on the work of contemporary artists and designers, including alumni and faculty of the School of Art and Design, the Natalie and James Thompson Art Gallery – endowed in 1996 by a gift from the estate of Natalie and James Thompson – has become a significant exhibition venue and educational resource for the entire Silicon Valley region. It is now the center of a University-wide collection of art as well. As the focal point of a network of eight galleries in the School of Art and Design, the Thompson Gallery sponsors over 200 exhibitions a year, providing students, faculty, and members of the community a unique opportunity to experience artistic expression and design solutions in a broad array of materials, processes, and approaches. Through its publications and website (www.sjsu.edu/depts/art_design), the Thompson Gallery creates a forum for informed research that challenges conventional assumptions, creating an atmosphere for better learning about – and living with – art and design.

◄

Help, 1983
Graphite on paper
6 x 6"
Collection Tai Fauci
Los Angeles, CA

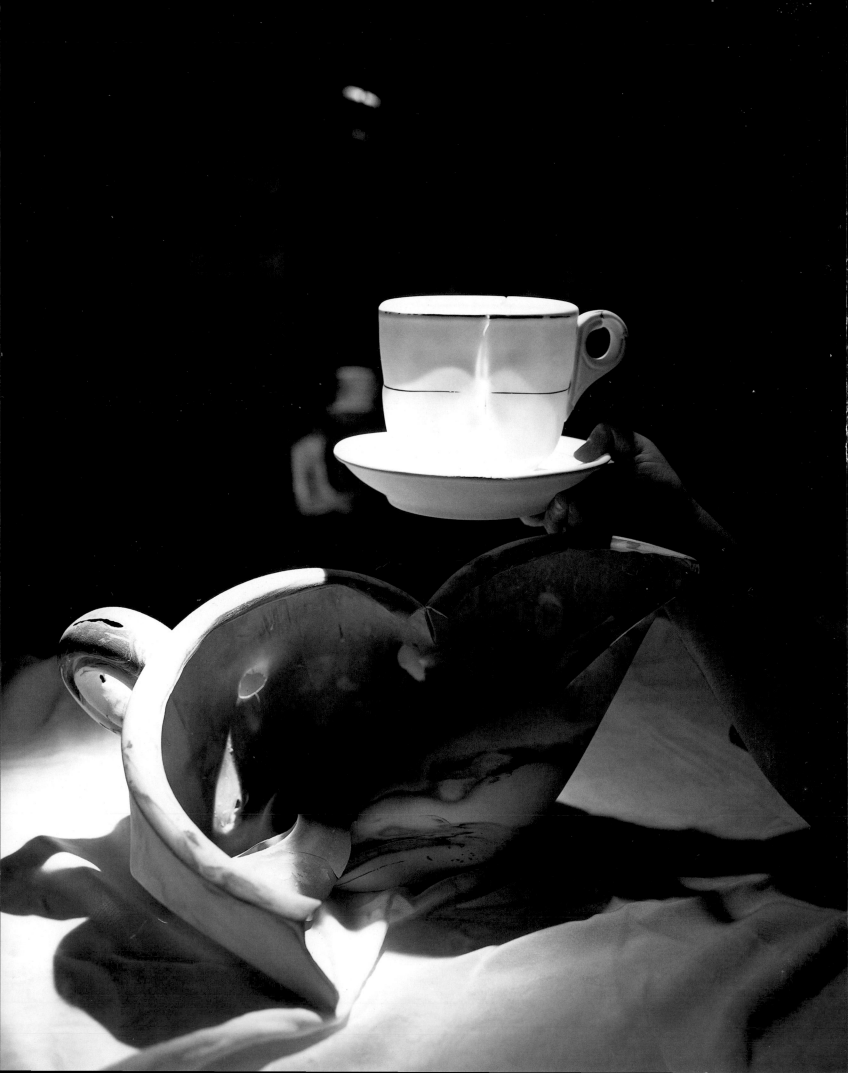

INTRODUCTION AND ACKNOWLEDGMENTS

Jo Farb Hernández

Director, Natalie and James Thompson Art Gallery
School of Art and Design
San José State University
San José, CA

This book documents a 25-year survey of Irvin Tepper's exploration of the physical and conceptual idea of the *coffee cup*. Tepper, a New York City-based artist and designer who is a professor in both the Fine Arts and Industrial Design departments at Pratt Institute, began his professional career as a ceramist, but subsequently explored other media as well. The exhibition documented by this book includes Tepper's ceramic cups, bronze cups, drawings of cups, stories about cups, and photographs of cups... a sufficient number of images that the depth of this – dare I say obsession? – begins to become clear.

Tepper's cups are endowed with animistic qualities; they hear, think, and, in later works, even speak, commenting on the stories that they overhear describing the human condition. For Tepper, the cup is the recipient of our stories and personal histories: a responsive albeit mute confidant as we pour out our emotions and feelings, plan our days, and maintain our friendships and business relationships over our cups of coffee. Tepper's work symbolizes and embodies the complexities of these personal connections. Because of the daily, intimate contact most of us have also experienced with the cup, we, too, can herald the affirmation of this humble object as it achieves the status of an *objet d'art*, without losing respect for its years of modest yet durable service.

Tepper has successfully married a variety of media and genre over a career spanning more than three decades. It is therefore of particular importance to organize an exhibition such as this at a university gallery, for often students may become so bonded to their own particular medium that they don't "think outside the box" in terms of other media or genre in which they could manifest their aesthetic conceptualizations. This kind of compartmentalization becomes particularly divisive between "fine arts," "design," and "crafts" programming areas, so showcasing an artist who freely moves back and forth between all of them, utilizing that which works best for each particular idea, may help students to break down their own self-imposed boundaries and thus free their aesthetic output.

Although Tepper's work is included in noted private and public collections internationally and he is the recipient of numerous honors and awards, there has been no recent exhibition focusing on his innovative straddling of aesthetic boundaries, and no in-depth, available publication exploring this work. This exhibition project and documentary book will fill that gap. We are therefore delighted to be able to organize and circulate this project from the Natalie and James Thompson Art Gallery in the School of Art and Design at San José State University, exploring, analyzing, and interpreting this involvement with the cup that has enthralled Tepper for over half his lifetime. We would like to thank the funders who have so generously and graciously acknowledged the need to exhibit and publish this work: Jerry and Debby Tepper of the Tepper Family Foundation; a California State University Research Funds Award; Kenneth A. Cowin; Dan and Jeanne Fauci; and Dotty and Arnold Tepper. Further thanks are due to the lenders to this exhibition, without whom the display would not have been possible: Marcie McGahey Cecil, Kenneth A. Cowin, Dan and Jeanne Fauci, Jim Friedman and Suzanne Stassevitch, Katie and Drew Gibson, Ben Liberty, John Martin and David Turner, Museum of Contemporary Art, Los Angeles, Orange County Museum of Art (Newport Beach, CA), Joseph L. Parker, Jr., Dotty and Arnold Tepper, two private collections, and the artist. Thanks also to all of the Thompson Art Gallery staff, particularly Theta Belcher, for all of their efforts in seeing this project through to fruition. And my special thanks to Sam, Larissa, Finney, Cristina, and, above all, Irv, who got me what I needed, raced with me towards deadlines, and creatively sparked the compilation and completion of this exhibition project, over roughly a million cups of our daily brew.

Centre Street Studio, 2002
New York, NY

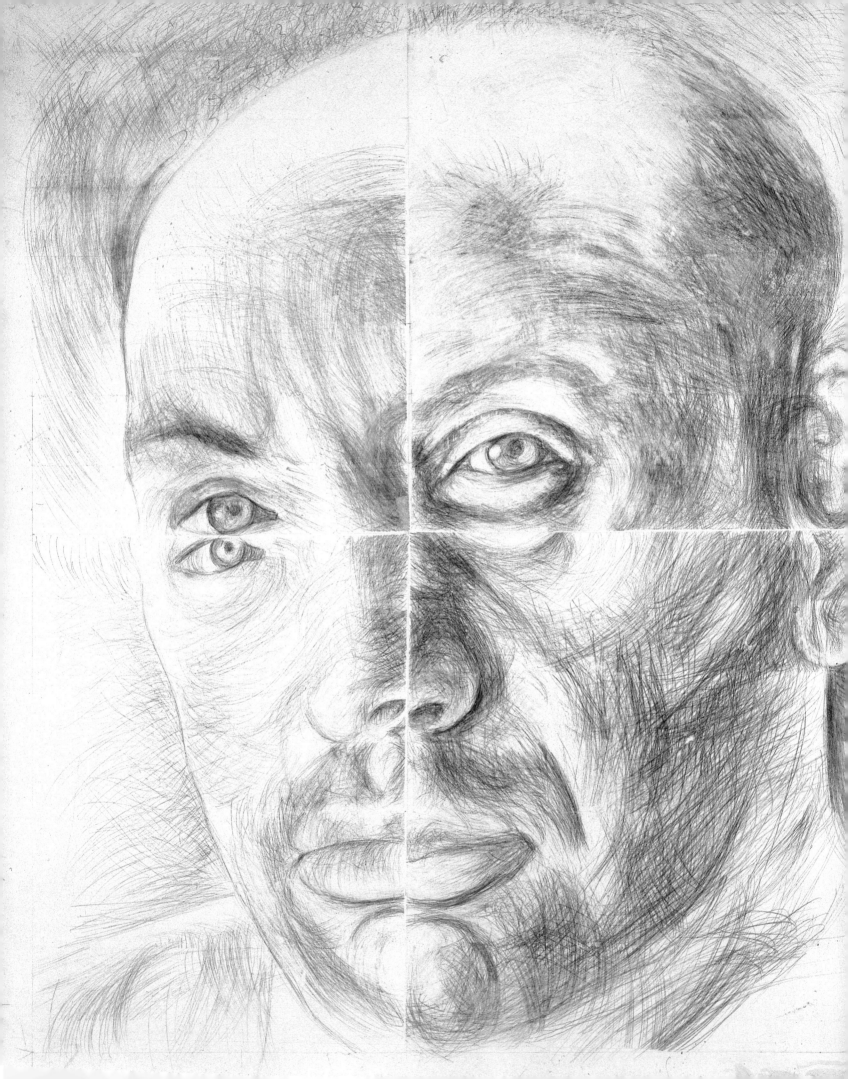

Artist's Statement

"I know you are not an angel, angels are so few, until one comes along, I'll string along with you"

— Milton Brown

For all her patience during the process of putting this book together, I dedicate this book to Geanne Finney.

From earth, water, and fire, I make cups that are thin, cracked, and on the verge of coming apart.

My cups are fragile, translucent, and made of porcelain.

They teeter, leak, and do not work.

They bear witness to past faces, events, and conversations.

They are metaphors in which they serve as a road map for what the cup has experienced, frozen in time.

Their fragility reminds the viewer that what matters is not the days we live, but how we live their moments.

Irvin Tepper
New York City 2002

Self Portrait, 1985
Silver point on board
17 x 14"
Collection Kenneth A. Cowin
New York, NY

Life with the Cup: An Interview with Irvin Tepper

Jo Farb Hernández

Director, Natalie and James Thompson Gallery
School of Art and Design
San José State University
San José, CA

February 10, 2002

Jo Farb Hernández: Some of your first experiences with vessels were a result of your teacher Ken Ferguson's interests in traditional Japanese pottery, when you were in your first years in college at the Kansas City Art Institute. These vessels were modest, even "humble," yet they had great aesthetic power. How did this "quiet" ware influence your own direction with ceramics?

Irvin Tepper: When I was at the Kansas City Art Institute, the only way you could study ceramics was to study pottery. And I wasn't really interested in pottery, but I *was* interested in ceramics. So when I got to the ceramic department Ferguson gave us an introduction to – indoctrination to – Chinese and Japanese ceramics. This was reinforced by the fact that the Nelson-Atkins Museum was next door. The director of the museum, Larry Sickman, who had acquired so many works from China and Japan, was still alive. The combination of those two guys was important, but in particular, Ferguson gave me an appreciation of those vessels whose shapes were not necessarily "intended:" the shapes that were "unintentional" to the form.

What do you mean by that?

You would make an object, and then somehow, accidentally, an alteration would take place. Then you would appreciate the accident itself, although some people would consider it as a mistake. You would consider those mistakes to be part of the aesthetic, like an Abstract Expressionist. In ceramics, that really came from the Korean and Japanese potters. When I was learning to throw, all those issues were a big force in forming my attitude.

So perfection wasn't really an issue? With so many pottery departments, the ideal is that of the perfect cylinder.

I had to deal with that, too. It was part of the technical training, that you could achieve a supremacy over the material. But at the same time you were taught to let it go. That was the duality of the teaching. I was striving to perfect [my craft], but at the same time, I was interested in the idea of how to utilize industry. However, at that time, utilizing industrial ideas wasn't considered a valid discussion. You couldn't talk about it, really; there was too much resistance. I said, 'look, we could sit here all day and throw tea bowls and make cups, or, you could have them all done on a ram press, have the machine do it. It would be your design.' But if you talked about it like that, the argument would be, 'it's not made by the potter, it lacks the touch of the hand,' and all that. If you brought that subject up, it was like bringing up some sort of sexual taboo.

Gallery Installation, Site, Cite, Sight, Inc. 1979
San Francisco, CA

As if it were a sell-out.

It was *more* than a sell-out. During the sixties when I was in art school, the fine arts majors were the people who really ran the place. The designers – and they had a pretty strong design program at Kansas City – were playing second fiddle to the fine arts majors. Today, it's design departments that run the show. This is particularly interesting to me, because it's the complete flip of the period when I was a student. So to bring up a design issue [at that time] was like, forget it. It's only been recently that ceramic artists have even been interested in talking about it. And a lot of art departments have dropped their ceramic design programs. It's a reversal.

The other thing was the idea that small things could be big ideas. And also that objects could have a life of their own. All of these ideas were out there when I was a student, and those were the ones that I bought into.

How did that set you up for the experience at the University of Washington with the distorted industrial cup, as a young graduate student studying ceramics? What led up to that experience that left you open to responding to this object in this way, enabling it to serve as a trigger for this theme and body of work?

It just extended that argument about industry and the machine. When I found that cup with the crooked handle at the University of Washington, it was the handle that first fascinated me. It was an art deco kind of handle. But the fact that the handle was put on crooked made it even greater for me, because it gave it that human element. So I stole it.

Did more than one cup have a crooked handle?

They were all slightly different, but most of them were pretty straight, up and down. Only that one had the flaw. After that first one, I started stealing more of those cups, just because I liked the cups' shape. It was later that I speculated on what the flaw was all about, and then I made drawings...but that was years later. I was only interested in terms of the shape. Those other ideas didn't really come till years later, you know, what I did with the collection or how I started to use the cup.

But do you think that the idea of the flaw or the imperfection of the Korean work carried over, perhaps subconsciously?

Well, in the sense that it showed that human quality that people kept saying didn't exist. I thought, OK, here's one, it was on the assembly line. But I didn't really take that cup and separate it from the others. I used them all. [That one] sparked my interest at first, but not until years later in terms of actually making something from that. That didn't occur until around 1975, when I had already given up working in clay, and then went back to it. The original cup was taken because of the handle, and then other cups were taken, but that one handle stood out more.

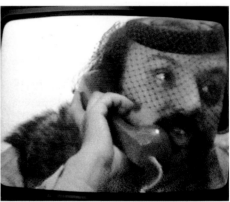

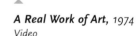

A Real Work of Art, 1974
Video

So you didn't necessarily see a connection between the Bizen and Inga ware and your own work?

No. But I think that was already embedded in my persona. It didn't *give* me that direction that you suggest in your question because it was probably already there. That aesthetic had already existed, although I was working in a totally different manner at that time, because I was studying with Howard Kottler, and at that time Howard was very much interested in the opposite kind of thing, the high expression of palace pottery. My education was a study of opposites. On the one hand I had studied with Ken Ferguson and got all that "humble potter" stuff, and then I went to Howard Kottler, who was only interested in the most pristine...

...precious...

...precious, high quality work. So it was that kind of opposite that interested me.

And were you rebelling against what Howard was doing?

No, not really, I was interested in that. It was a natural carryover. Because I was never interested – but I became interested – in the Kansas City attitude once I was subjected to it, but it wasn't my natural preference, whereas the other one I was definitely interested in. So out of a grudging appreciation I learned that [Kansas City] aesthetic. And actually I was quite a good potter. I made a lot of pots and I was very proficient on the wheel. But by the time I graduated, I had already shifted gears, and I had already started to express what I really had been moving towards, a more personal kind of art statement.

And then you wound up with Kottler, who was very into "formal."

Well, formal wouldn't be the word I'd use. Howard was interested in making things come alive, in having the object become real. I think of "formalist" as a much more academic kind of term than the way in which Howard approached his work. Howard would approach things as something special, something that was out there, that was different from anything else. He had that perspective because he was an outsider himself, in society, as a homosexual. He wasn't a traditional ceramic artist, and that interested me. And I was also interested because he used certain industrial techniques, like decals. But *I* taught slip casting to Howard and the others at the University.

Where did you learn how to do that?

I learned that in Kansas City, through the industrial design department. Ferguson made us all go over, and learn how to make a mold, although not necessarily how to slip cast. And we all tried it. Ferguson didn't really know how to deflocculate clay or do any of those kinds of things. So I got the basic introduction at Kansas City from a mold-maker who had worked in industry. Ken took us on a trip to the Dickey sewer-pipe factory, the largest sewer-pipe company in the world, in Kansas, and the only company that made salt-glazed sewer pipes. That interested me, but I couldn't get it going, because none of those guys around me were supporting the notion. We tried some slip casting, but none of us really knew what we were doing. And then Erna Brenner, one of the women that took night school class – you know, the kind that buy the molds from hobby shops – she and her friends gave us some hints, and they taught us about low temperature, and China paint, and stuff like that. We didn't learn it from Ferguson, we learned

it from those women taking night school. Hardly anybody seriously working in clay knew what they were doing with that stuff at that time. Some people were using it on the West Coast, but *they* didn't really know what they were doing, either. During the sixties and seventies it really developed. Now you see it all the time, and people write papers about it, but then, we didn't know what any of that stuff was. We'd just go to the store and buy it. We thought of it as a funk material, all that China paint and stuff as a way to express funk ideas. I used China paint to decorate ceramic hamburgers and hot dogs. But Ferguson said, 'why don't you make some more nice teapots instead? Make some more nice teapots and casseroles and go to Alfred [University].'

So you started out in ceramics, then moved into more conceptual video and photographic work.

Right, when I was in graduate school I got interested in photography.

What made you go back to object-making?

When I started drawing the cup, the first cup. I started making these drawings in my notebook because I needed something physical to do. All that photography and videotape was too ephemeral for me. I wanted to do something more grounded, so I started drawing. And I was never a very good drawer, so I thought I would work on my drawing skills, and it would be like meditation, and I chose that cup [as my subject].

This was in San Francisco?

Yeah. After about the third drawing, I realized that what I really had to do next was to make a cup that would express the notion of something that was alive. So that's when I made a mold of the first cup. (I had somebody else make a mold of it, actually.) Then it took me about six or seven months to figure out how to get one finished. I wanted to make it thin, but yet aged. So I put age into the piece by breaking it up and putting it back together, and then sanding it until it was paper-thin. But what would often happen is that it would fall apart in my hands while I was making it.

While you were sanding the greenware?

Yeah. It took me about six months and I finally got *one*. And from that one, it took me another five or six months to get a second one. I didn't really know what I was doing. I would cast a bunch of them, and I kept sanding them, and then I'd lose eight or nine or seven out of ten.

You'd lose them in the firing, or before?

No, before. They never even got to the kiln. I don't know how I eventually figured it out. I was making drawings, and then I'd make a cup, and it would break, and then I wouldn't start another one for quite a long time. I think when I was in San Francisco I made seven or eight small cups, maybe. And nobody bought them.

They were small cups without saucers?

I made a saucer for the first one, after I figured out the cup. I adopted a saucer, because it was a cup that originally had no saucer, but I just thought it would be a good idea for it to have one. As a thing to look at. Instead of just a cup, it now had kind of a pedestal. It was an afterthought, actually. So I made a plate mold, and cast the saucer. I think the first couple of cups just didn't have them, and then later they did. It also allowed me, when I started introducing different colors, to have patterns in the pieces.

Those were colored clays?

Yeah, that I colored myself. I made the porcelain myself and colored the porcelain.

What was the relationship of the cup series to your other work in terms of media? Were you doing other ceramics?

No, at that point I was just drawing, and the cup was just a model. I stopped working in clay around 1972. When I first got to Oakland I made a couple of pieces, but that was pretty much the end. I didn't take it up again till about 1975 or '76.

How did you see that fitting in with the video and the conceptual work that you were doing at that time?

I didn't see it fitting in at all. Except that the drawing was a conceptual notion, because you could follow my steps in the drawing. The drawing was an object, which, from a purist conceptualist point of view in the 1970s, was not considered a good thing. I remember all those San Francisco guys, like Tom Marioni, gave me trouble then: 'Oh, you've become a traditionalist!' I considered the drawings highly conceptual, because I thought they were records, and yet at the same time you could engage yourself in the drawing in a way that you would never engage yourself into an illustration. And so I considered the drawings conceptual even though those guys didn't. And now, in the second or third generation of conceptualists, you see objects being made all the time. Even *those* guys now are all making objects. [laughs] The cup for me was an object that became "inner ocular" for dialogue.

"Inner ocular?"

Yeah, you know how people have a life, and they show the wear of their life on their face, or on their body. If you go to a place and have coffee or tea, or a drink, oftentimes people use that social event to interact and have a conversation. I was interested in the object that overheard that conversation and was part of that interaction, and as a result showed it in its appearance. That's what it really came down to; I wanted the object to have the sense of hearing everything, listening to all this, having its own life.

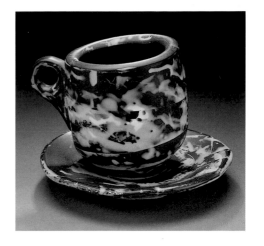

Cup and Saucer, *1984*
Porcelain
6 5/8 x 8 1/8 x 8 1/8"
Collection Los Angeles County Museum of Art
Gift of Dan and Jeanne Fauci
AC1999.41.1.1-.2
photograph ©2002 Museum Associates/LACMA

Untitled, *1999*
Porcelain
5 1/2 x 8 x 8"

Janet Delaney (American, b.1952)
5th Street Studio, 1978
Chromogenic print
San Francisco, CA

Eavesdropping.

Yeah, the cup is an eavesdropper. And also it has its own kind of reality. That's what I am interested in. I made it out of porcelain because porcelain is translucent; light passes through it. This, for me, gives it a unique life force. That's why I chose it; I conceived it that way even though I didn't know how I was going to make the cup. The drawing took my idea to a certain place, but then the cup really had to take over. Once I really understood how to physically make the cup, from an intuitive, creative standpoint it worked differently, whereas the drawing was a more highly neurotic activity. I never considered myself a very good drawer, so it was all a challenge.

The ceramic technology was a challenge in a different way, though, because you had to become partners with the kiln. The kiln was an element of the creation, because it changed the object from how it started out. I tried to make the cup absolutely perfect and pristine, and then I would "take it down in life," I would break it up and then put it back together. I'd wear it down through sanding, and how it wore down was totally abstract. I wasn't looking for this one to do this, and that other one to lean that way. I don't think about it at all. I just kind of sand them and break them. Sand 'em and break 'em, sand 'em and break 'em. And then eventually, when it goes in the kiln, the kiln changes it. At first I was looking for cups that were still almost perfect, yet had a flaw. And then as years went on, I decided the whole thing was a flaw. Then I would just take the cups and melt them. It took a while to develop the aesthetic, and also at the same time to develop the technique.

With the drawing, as I got better, I had to make things more difficult, by making the drawings larger in size, or using more difficult subject matter or a different physical technique, like switching from pencil to silver point to pastel, materials that I wasn't as familiar with. Those were the ways that I was able to keep it fresh, so that it would never become an illustration. It would never become perfect, even though I tried. I figured that if I tried to make the drawings perfect there would always be a screw-up, and that would be the thing that would be interesting. That's referential to the Korean and Japanese asymmetrical aesthetic, going back to your earlier questions. All that has always been embedded. I wasn't thinking consciously about it; I was already there.

This discussion focuses on issues of "fine arts," yet from the very beginning there was an industrial design component as well.

Right. I'd always had the notion of using industry, but I never really knew how, and I never had access to it. I would have loved to have had access to the technology of industry. And Howard, through his industrial decal work, just whetted my appetite even more, about the possibilities. We couldn't make those things; we had no access. If you could go into a factory and you could make commemorative plates, what would you do? Instead of having a picture of Mount Rushmore you'd have your own disaster scene, or whatever you wanted to put on there. And then you could get creative with it. People have used it since then; that idea is out there and being used now, but back then it wasn't.

And now, having taught industrial design at Pratt, do you see a change in how you're approaching the material conceptually?

The opportunity to do teach I.D. at Pratt has allowed me to prove something that had been sitting dormant in me for twenty-something years. Finally I was able to do it my own way. And I see that others are interested now, even in traditional ceramics programs, although people from traditional crafts programs still put it down. They say design and industry can never replace hands-on craft, partly because the craft people still have this arts-and-crafts notion, the William Morris notion, about humanity not being lost after the industrial revolution. That still persists. Where I teach, I realized that the design people have all the money, they have the 3-D rapid prototype machines, they've got the engineers. You could be much more creative behind that, if you're allowed the freedom to do it. Now I'm not standing alone or in isolation as much. I wouldn't say that everybody's there yet, but the attitude is starting to shift. That's what people are questioning me about now. Some school group was touring Pratt, and somebody came up to me and said, 'In this industrial design class, you actually have them make the ceramics?' And I said, 'Yeah, we make the ceramics.' 'Really? I'll have to come back and talk to you.' It's still bizarre to them. And when I give lectures, I always show the work of the students in the I.D. program now. Because it turns them on, and it is shocking to them that in fifteen weeks, you could teach somebody how to work in clay and produce a finished form. That's what blows them out. You could never do that in a hand-building class or a drawing class. Using industrial techniques, you can actually transform your idea into a finished state.

What about the role/function for imperfection in the fine arts compared to in industrial design?

For me, I'm interested in seeing thousands of functional objects with the same design, but at the same time, the idea doesn't bother me if things are different. Now I am seeing designers actually using the same mold but the results change slightly with each piece, like the Dutch design group, Droog. I'm starting to see that in other industry forms, as well, but it's always been a battle between industry and the artist. Industry thinks about making everything highly crafted

Sake Cups, *2001*
Porcelain
1 3/4 x 2 1/2 x 2 1/2" each

Sake Bottle, *2001*
Porcelain
7 x 5 x 5"

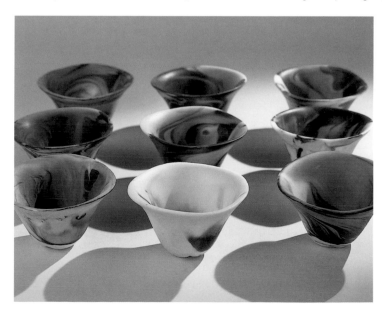

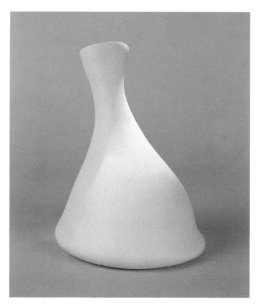

but the same. For example, my friend Marek Cecula went to Poland, and he took a standard issue china plate and tried to get them to dip it in blue stain on the edges, so that there would be just a touch of the blue on one edge. They started making little jigs and stencils, so that the worker would know exactly where to stop the dip. Then he had to say, 'No, this is how you do it. You dip it, you do it, you dip it, you do it.' It took them weeks before they got it! There are designers now who are starting to play on that, but I don't think it'll ever catch on in a big way, because the factories are constantly trying for standardization, and it's just too much against the grain. But who knows?

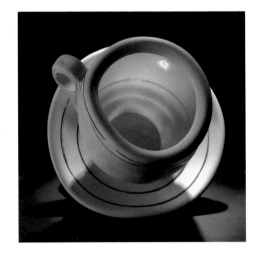

What about other ceramic dinnerware producers like Luna Garcia, whose work is intended to look a little funky, a little lumpy.

What they've done is something different. I would consider them more an art pottery than an industrial ceramics factory, because they're basically using hands-on techniques. And from the standpoint of a contemporary art pottery, they're making a nice product. I'd consider industrial more like a Rosenthal factory, or Noritake, or Lenox, where you've got highly crafted work, and also because of the production: we're talking about companies that are capable of making twenty or thirty thousand plates in a day. Luna Garcia is also not so much into design as they're into cultural folk quality, which is different, I think. Even though design reflects culture, it's also about some other kinds of issues.

Such as?

Issues of the dialogue of design, like touch, function, stuff like that. Much more fundamental. Luna Garcia's objects reflect a cultural expression that's an integral part of the form. They're much more interested in the cultural reference or setting, whereas contemporary design really considers other kinds of sensory considerations and then reflects a much more international, current aesthetic. Technology, for the craftsman, has to do with finding and then fashioning an available material into something useful: you take a piece of wood, you cut a bowl, you've got a bowl. Whereas a designer has technology at hand, with a support system of engineers, factories, banks, and specialists, and then applies all of that to the final object.

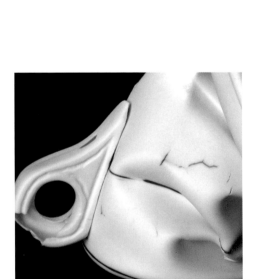

Caught Napping, 1999
Porcelain
8 1/2 x 12 1/4 x 8"

What about the concept of humanity within these genres, as revealed in the metaphor of your over-hearing cups?

What's going on in industrial ceramic design today, which interests me quite a bit, is interactive objects. You may see objects that don't necessarily have balance, but they have a playful [quality], so that when they're on the table, they move around a little bit, but don't fall over. There are a number of designers that are doing that kind of thing, so the viewer has an active participation with the object in that sense. The function is not necessarily straightforward, and the object can be transformed into something else. That gives it a big human quality. If I don't watch out, I'm going to be behind the curve on that. For example,

Philippe Starck designed a teapot that rocks. Or the bowl that stands straight because of the nature of the shape, and when there's something in it, it falls over on its side. Stuff like that is starting to happen, more and more, and that's just great. The other thing about design is that it doesn't focus on a personal, political, or social idea, it focuses on a more purely aesthetic point of view. And that's why design is so strong right now. On the other hand, art guys are considering the object and not the function, although it might be referential, like [Ron] Nagle's cups. Fine artists make personal and political references, considering the object and not the function; and in contrast, the designers are more apolitical, and focus on a more general aesthetic and style. For fine artists, it becomes sculpture: if it's a cup, it's referential, and it's art. My cups always started out as industrial shapes, made as sculptures, then became represented as a metaphor.

◀ ◀ ◀ ▶ ▶ ▶

Several of the documents that have been published on this body of your work refer to the cup as a "modest" form.

The term "modest" is offensive to me, as is the term "vernacular." I take a lot of pictures of hand-painted signs, and sometimes I show them in slide presentations. I get questions like, 'I've noticed that you have used a lot of vernacular imagery of food,' and I say, 'you know, somebody painted that.' [laughs] Even though they didn't sign it, somebody painted that. It was somebody's interpretation of a doughnut, or a French-fry. It's the same argument, you know, that some artists are less important because they're painting landscapes instead of battle scenes, or whatever. I never know what to say about that, other than to say, for me, anything goes. What could there be that would be more important than a cup? [laughs] That, you know, sustains your life. In fact, because it's omnipresent in one's life, I guess it's just considered humble. Or maybe it's the fact that I choose a restaurant cup, instead of choosing Wedgwood or palace porcelain.

Your cups seem to have become more animistic and, simultaneously, more aggressive over the years. They have become less "modest," serving as recipients of information, and more forthright, proclaiming their own comments and opinions. Does this reflect your sense of the changing intimate relationship people have with each other, or is it all about art, and the changing relationship people may have with art?

First of all, the cups started out being the size of a cup. And then I realized that in order for them to be considered more sculptural, they would have to be scaled up. It was a matter of making them more noticeable.

Less "modest?"

Less modest. It was about how to get the piece to draw more attention. So I started scaling them up, and I scaled them up twice. For a while they were five inches, and then they became close to twelve inches. With a bigger canvas

to work on, I could do more things. After I got technically better, I could express myself more and I could make the piece less stable, which interested me. I also started relying on the kiln as a creative tool. I would put the cup through the kiln several times, to get the shape that I wanted...well, not necessarily what I wanted: you just kind of get what you get, and then you have to decide. For example, if a piece goes through the kiln, and it doesn't really speak to me, then what I usually do is stick it back in the kiln and take it up to a higher temperature, and see what it does then. If it doesn't do anything for me then, I might put a weight on it, or change the slant, or fire it hotter or longer, try to deform it in some way so it will take on some characteristic that might say something to me. If it doesn't do it after that, I usually take a little hammer and put a break into it, and then if the break doesn't change it, if it doesn't do it [for me] then, I'll just throw it out. That's how I approach it. It has to speak to me.

I never thought I'd be doing the same thing for so many years. I won't work for long periods of time on the cups, so every time I approach making them again it's from a different point of view. For example, when I first came to New York, I started thinking about how I could make the cup have it's own grid. That's when I started putting the horizontal bands into them, so when I'd grid them again in the drawing there was a double grid: the cup grid and then the drawing grid. It was a formal consideration. Later on I abandoned that. Then I made the bigger cups, and it was a matter of how much I could screw them up before they'd fall apart. Part of that was technical; I was getting better technically, and staying ahead of the curve, trying to do something that no one else could do. The whole notion of that metaphor of the dialogue is so strong to me, but now it is not as intimate. When it was a smaller cup it was much more precious; I turned it much more into an "Object" by going big, and that was part of the consideration.

At first many of your cups were solitary, sometimes existing even without a companion saucer. In later years, however, you did a series of cups that were stacked on top of each other. What significance did this have either in terms of your conceptual references about the cup, or in terms of formalistic considerations?

When I started stacking them up I no longer had that same relationship to the object, because I was starting to see them as families. It's the same as when you scale them up, they become more noticeable; when you group them, they become more powerful. And that also goes along with how sensitive people are or are not to seeing things. When you see more, more is more, and less is less. That's where I am with it now.

But of course when the cups are full of each other, they can't be recipients of a story, they can't eavesdrop.

Right, they become something else, and that doesn't bother me at all. Now, as a group, they've become much more of a formal statement. The first part of that is how can you transform an idea, and then, secondly, how can you technically

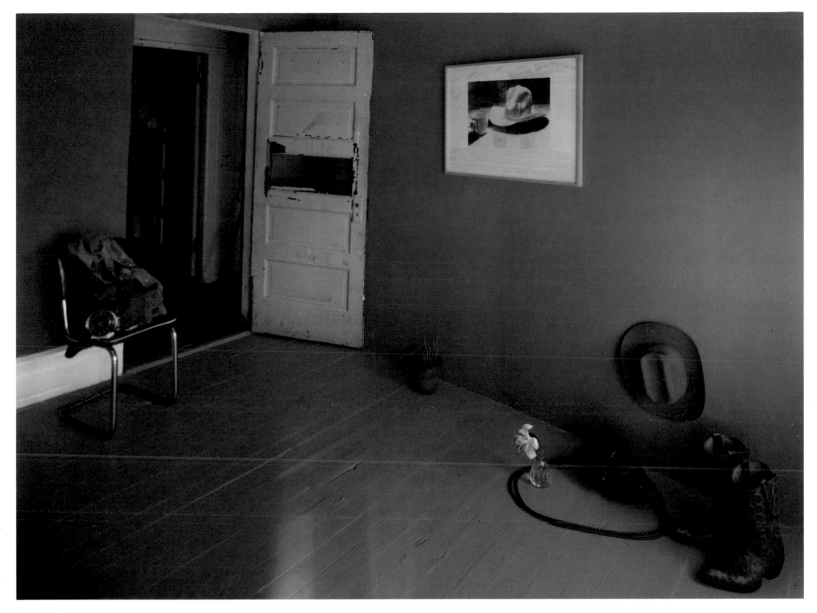

pull it off with no fear. My intention is that the metaphor still exists, and now it's got company. I haven't considered, as yet, drawing any of them, but I'm very interested in photographing them. I'm also interested in the environment that they live in; that's why the recent ones are called *The Happy Rooms of Mystery*. I'm interested in them living in some other place, in some other kind of life, with each other. That's how it's changed for me.

◀ ◀ ◀ ▶ ▶ ▶

Talk about the relationships that you created between the cups and the "3-D props," as you have called them, like the checkered tablecloth.

When I first started photographing [the cups] on the checkered tablecloth it was a way of visually adding to the 3-D effect. Because you'd have a foreground, a middle ground, and a background, when you looked at the image visually you would see dimensions. That's why I used the checkered tablecloth. And plus I had it around. But if it hadn't been the checkered tablecloth, it would have been some other pattern, so your eyes could have distinguished the foreground, middle ground, and background, which is how stereo work works best.

Janet Delaney (American, b.1952)
5th Street Studio Bedroom, *1978*
Chromogenic print
San Francisco, CA

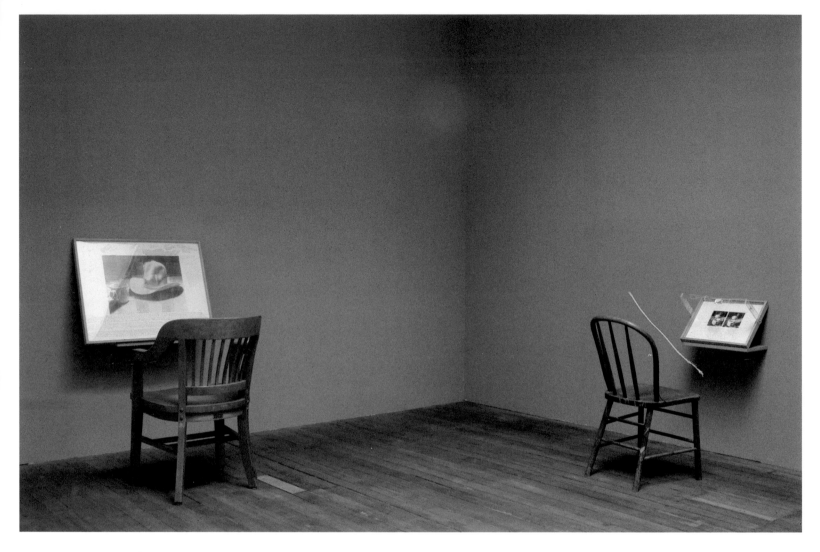

What about the cardboard pedestals?

Since I considered the cups so fragile, as if their life could go out at any second,
I always hated their presentation on a shelf, which is what most collectors did.
I always wanted them to have a life independent of a shelf of objects, and always
be near a window. [With the cardboard] the cup was able to have its own pedestal.
It also allowed me, from a Chinese philosophical point of view, to have fire, earth,
air, metal, and wood all combine and interact. For example, because the cardboard
was essentially industrialized wood, and the clay formalized earth, it was a way
of sending out another statement about fragility. I'd been aware of Frank Gehry's
chairs, I was a big fan of his cardboard pieces, and when I saw them, it really
turned me on. I realized that cardboard had a fragility, and I could make it look
really fragile and transitory. So I started playing with that. I could burn it, and
I could transform it. I could make a perfect shape out of a material that was
basically cheap, and I could easily find. And it was light, so I didn't need any heavy
equipment. Setting the cups on this non-traditional material appealed to me. Plus,
I had a cardboard mailbox when I was in San Francisco; it withstood the rain and
weather for five years and nothing ever happened to it, so I figured that cardboard
is pretty strong stuff.

Gallery Installation
Site, Cite, Sight, Inc., *1979*
San Francisco, CA

Why were you interested in the cardboard being near the window?

Not just the cardboard [but the cups]. In my San Francisco studio I had all those bay windows, and from 4:30 in the afternoon on, the light would come in at an angle where it would hit the cup and it would start to glow. I was always interested in that light. And I thought, foolishly, that everybody would see it that way, but they don't [laughs]. You can't control how people view your work. A lot of people didn't want the cardboard [when I first showed them], but at my recent show in Boston, they just went off the chart, people responding to the cardboard. At the time they were done, years earlier, nobody responded to them. At least no collector did.

Did you ever do cardboard pieces to stand on their own?

Yeah, I did 14-foot sculptures at the Djerassi Foundation. When I get time I think I'm going to make more. The shapes are still interesting to me. I should have separated them a lot earlier, but I was so committed to the cups. When I did that first show at Paule Anglim's, I got a lot of shit from Paule about them. A lot of the collectors didn't want them. I think I only sold about three or four of those pieces. And then Manuel Neri came up to me and he said, 'I loved your show, but I thought the bases by themselves were the show.' I hadn't really thought about them that way, even though I was making separate pieces. And then when I looked at that group I thought, you know, he was right. But I couldn't figure out how to show the cups. I didn't want to show them on a table, and I didn't want to show them on a shelf, I was just searching. And I'm not sure if I've ever got the answer. You know, Bob Graham finally came up with that pedestal to show those figurine pieces, and the pedestal is more interesting than the figurine. [laughs] I've never come up with that perfect [combination].

◄ ◄ ◄ ► ► ►

In an interview you did with Paul Schimmel in 1983 you recalled that you originally used tiny diode lights to light up the inside of the cup, before you were satisfied with a translucency that you were able to achieve on your own. At that time, were you able to achieve the kind of light that you wanted in your cups?

Yeah. Where the porcelain is thin, you can get light. As I just got better and better and better, I was able to make it thinner and thinner and thinner. You could definitely do it, but the angle had to be right.

Were there technical trials and errors as you began this process?

Oh yeah, millions. Depressing problems. In '75 or '76, I actually started to make the cups, and I think I didn't really formalize the technique until about 1982, until I came here [New York]. I hired Jane Bauman, a former student, to help me sand, and in order for her to do it, I had to develop a strategy of steps, whereas before it was not formalized. And through working with her and teaching her, I really had to formalize a method. I hadn't even thought about organizing it. I didn't have that kind of organizational skill, in the front of my brain. But once I had her working, then I had to figure out a system, and then I was able to push that system, and that's why the things transformed.

Had you ever considered alternative techniques than casting?

I haven't seen [an alternative technique] that I've liked yet. I guess in a factory you could make them in another way, but you would still have to manipulate them. You could make them in a jiggering technique, and that could be interesting, because the clay would be stronger. But I don't know if you'd be able to get the same kind of melt out of it, and there's still a hand element to it that you couldn't avoid. Because with the sanding, I attempt to also bring the spirit into the piece. Without that, it just stays an object. It's how much time you put into it, and how much courage you have to push it to the edge. Those are always the best pieces, the ones that you push, that you've really taken far. Not necessarily the ones you've put the most time into, but a lot of time.

Do you ever use Dremel tools or anything mechanical?

Tried all that. Too harsh. Tried it for polishing, too. And I tried sandblasting. I had some semi-interesting effects with sandblasting; I wouldn't discount it.

Janet Delaney (American, b.1952)
5th Street Studio with Tepper, *1978*
Chromogenic print
San Francisco, CA

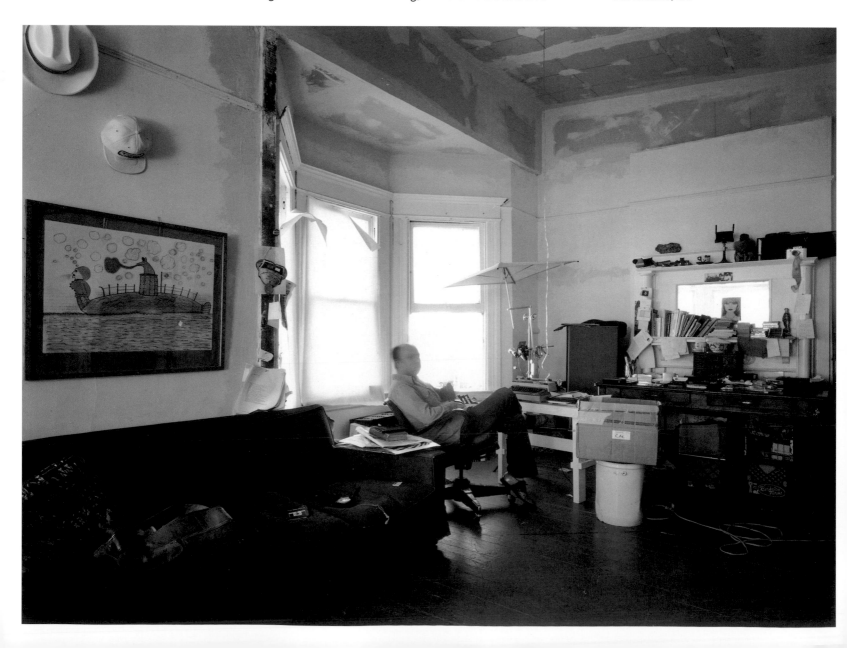

When and why did you start with the use of color?

Black started first. It was like a filter for the white, because wherever there's a color the light doesn't pass through as easily. The original idea was just to take black slip and put it in the cracks. I didn't necessarily mean to cast it, but then I had all this black slip lying around, so I just started casting the cups in different colors, in layers. So I had a white layer, black layer, white layer, black layer. Then when I sanded it, the lower layers came through. I wouldn't know what patterns were going to emerge, but I could work with the pattern as I sanded.

In what other ways has your technique changed with the porcelain cups over time?

The various techniques I employ have gotten better. When I started making those cups they were absolutely, perfectly thick, just like a normal cup, and then I'd thin them out from there. But they'd take weeks to make. They still take a long time, but where it used to take weeks, now maybe it takes three or four days. Now I can cast them really thin, because I know how. Before when I'd cast them thin, I didn't know when to take them out [of the mold], so I took them out too early, and they'd fall apart in my hand. The greenware wasn't stable. I also have a lot more patience now. Technically I understand much more how to work with clay; I'm much more mature about it. I don't work with it every day, but if I did, I'd probably figure out still more techniques. But I don't want to get *too* good at it, because if I did, it would become just like manufacturing. I try to keep it out of that range.

The technical thing comes *after* the idea comes. I'd look at the cups for a long time, and I wouldn't work with them for a year, and then I'd think, for example, 'if they'd slump, that would be interesting,' so I'd slump them. Or if I'd do this, they'd do that, and I'd start again. That's how the cups have stayed in my mind... to continually deconstruct the theme and make it interesting.

In 1983 you said that you were "parenting" the cups, and that you had "no control over the destiny of their future. Some are going to be OK and some will turn out bad." Clearly you have gained control over the technique to a much greater extent... do you still feel that same patriarchal emotion about the cups, assuming that you are much more able to effect the end result with greater certainty?

Yeah, definitely, but I wouldn't say I can effect the same result with greater certainty. I still feel like I'm parenting them, and I feel like I've improved technically, but I don't feel that I have any control over how they ultimately work out.

Why do you say that?

Because I'm using the kiln as part of the creativity, and you never know exactly how the cups will turn out at the end. I have a greater degree of expectation; I think that would be a better way of putting it, as opposed to certainty. I don't have any certainty. I know if I don't break it, and it gets to the kiln, it'll probably come out.

Self Portrait Blowing Smoke Rings in 3D, *1974*
Half-tone study for silkscreen
2 1/4 x 4 1/2"

And if I lean it a certain way, or if I put a weight on it, it'll bend. I know more technically. But I can't tell you it's going to do this or that, I can't do any of that. It's more by feel. In contrast, with drawing, I know what I can expect with the material, but I can't do that with ceramics. It's much more of an Abstract Expressionist approach. I don't think you could ever do it, unless you just made the object exactly the same. Clay only allows me a short window of opportunity to manipulate it.

And that window is...?

I have a window when I first cast it, and then break it up, and then I have a window when I fire it, and that's about it. When you sand it it's really about how much time you want to spend.

◁ ◁ ◁ ▷ ▷ ▷

You have said that the original drawings of the cups, which had personal, diaristic notations, "weren't meant to be shown," that you were doing them simply as an exercise, mimicking the way that a notebook with daily personal notations had helped you to lose weight in the 1970s. When and why did you begin to consider the drawings as works of art that would be shared by others?

Actually, I didn't. I was doing mostly videotapes, and I went to Portland to do an exhibition at an alternative art space, and I had brought those drawings with me. Maybe unconsciously I brought them with me to see what people thought, and I showed them to a few people, and then I put them back in the bag with the videotapes. On my return to San Francisco, I hadn't even unpacked my bag when I got a call from Paul Kos, to come over to his place to meet this museum director from Texas, so that he could look at my videotapes. I just brought the bag, and the director, Jim Harithas, started going through the bag. I didn't pull them out, I had just pulled out the videotapes, and the bag was open, and he started looking at the drawings inside the bag, and then he said, 'I'm sending my curator over to put you in a show we're doing.' And that's how it happened. It's like my career was a career based on not understanding what I was doing. I had no idea about these drawings, I was just doing them to become a better drawer. Harithas was the one that declared it.

*Was there a commensurate change in the drawing's narrative after this
conceptual change...becoming somewhat less personal and more apocryphal?*

Yeah. The narrative changed partially because I started from a neurotic place,
and there's only just so much neurosis that you can deal with. You finish with
it when you get it out. Also, when I moved to a larger city, to New York, things
became less personal, too, and a little bit more formal. My issues just changed.
I'm getting ready to do some other drawings, and there will still be something
from that neurotic place, but there'll be a different perspective: it keeps changing.

*You have said that you wanted the drawings to have a "seductive quality that
would draw a person into it. Most people who look at art aren't interested in
a personal life experience." Did you consciously reduce your personal comments
in order to seduce the viewer more?*

No, I think the personal ones will seduce them, too. What I mean by "seductive"
is that the first sentence of the story should be interesting enough to make the
reader want to read on to the next sentence.

*But are you more self-consciously aware of the audience now, and working for
them, rather than as much for yourself?*

It's hard not to be. That's the trick, to get yourself in that place where you don't
think about the audience. For example, one cup will express one kind of feeling
to me when I look at it, so when I'm drawing it I'm thinking about that feeling,
and as I'm drawing, the story emerges. Sometimes if you come from a really
deep, neurotic place, other people are thinking the same thoughts, and don't
express them. That's always been interesting to me, that somebody will say, 'you
know, I had that thought about that, too. I felt the same way about that.' [laughs]

In some of these drawings the handwriting shifts a lot, because it's done over
such a long period of time. I only write when the actual line comes. I'm not think-
ing first I'll write this and then I'll write that. I don't think about it in a linear way.

So you sometimes write a phrase at a time when you're not drawing.

Right. Or while I'm drawing, I'll write a comment down on the edge of the paper.
I used to write directly onto the paper, and there would be a lot of misspellings
and grammatical errors. Now I write it down first, [laughs] and then go back and
try to clean up the grammar and the spelling.

And why do you think you need to?

Just because I'm less embarrassed. [laughs] And also sometimes the language
is not clear. Because I'm too spaced out, or I think I've written something and
I haven't written it at all. So I just try to clarify it.

Is there a more focused intent to evoke "emotional content" with these more universal stories, as opposed to the more idiosyncratic and personal notations of the early diaristic narratives?

I always try to choose words for their emotional impact. I've always been interested in the writing of Celine, and of some of the beatnik guys like Kerouac and William Burroughs. Also J.K. Huysmans, although he's a little less emotional. I always admired Celine's writing style, although I've only read him in English. I've always admired the fact that he tried to boil the words down into some kind of emotional state, so there would always be a certain urgency in the story. I don't think I've achieved it as well.

But isn't that different from your earliest drawings?

In the earliest ones I didn't really draw on a literary source, not directly. I was really just making a diary. Then I tried to figure out how to formalize that emotion and make it even more emotional. Let's say you're writing something down, something you're thinking about. How do you universalize that thought so the word itself will evoke a response in somebody else? Then you're really getting into writing, and that to me is the toughest of all media. You get into choosing the right word that will electrify the reader's mind, and that to me is a much bigger challenge. I've become more aware of it over time, although I don't consider myself that literary. It's like the difference between [William] Wiley and [H.C.] Westermann. Westermann is trying to do word play, but he's also got a loaded message. And Wiley is getting stoned and is making these dumb statements that in time look pretty stupid, when you go back to them, although I thought they were great at the time. But they don't hold up. You try to write something that holds up. I don't think mine necessarily always do, but that's what I try to do with the stories. I try not to do anything stupid that I'll regret years later.

Do you have more distance between you/your life and the later cups? Are you more of an observer than a participant – in other words, has the balance between being "inside" versus "outside" the experience shifted?

I'm sure it has. Making the cup is physical. I don't start getting emotional until I start making the drawings. It's more a physical, visual look with the cups, because I don't know how they're going to turn out, so I don't try to anticipate it. But I'm sure that it's reflective, when I go into the studio, of whatever attitude I have at that moment. I don't think about it, though. I don't say, 'I'm going to make a group that's going to do this or that.' I just start making them. Then, when I choose to start drawing them, they have a powerful, emotional pull on me. It never really changes, it just gets more sophisticated.

You have said that "The drawings don't take physically that long, but the stories can take forever."

If I sat down and just made the drawing, a visual representation, and just grid by grid drew it the way I do it, without thinking about writing a story, they would take a tenth of the time. I don't usually draw unless I'm in that right mode. Unless I'm in that right, neurotic state there's no point doing it. It's different than if you're an illustrator,

because then you just sit down and start illustrating. But I'm not doing that. I know the angle I'm going to use, and I know that it evokes a certain emotion in me, visually, in my mind's eye. As I draw it, I figure that it will make itself. Because I cover up all the areas other than the one I'm working on. So I know where I'm drawing, but I don't know how it's going to look next to the other section.

You still cover up the other areas?

Oh, absolutely. That's the part that's fun. Then it becomes a quilt. I figure there will be a number of mistakes that will be visually interesting that will add up to a drawing. I don't think about it in any other way. Those formal kinds of considerations are just put into it before I start. I don't try to just show you how great I am at drawing. I don't attempt to style, you know, like a Seurat drawing shows the certain kind of way he had of making his tones. I work much more by feel, and I change whenever I feel like it. Although I'm sure, because I've made so many drawings, that there's a certain constant now, but I don't attempt to show my move. I hope I never have my move. [laughs] I'm sure it's there, but I don't think about it too much. Because it allows me to be lazy when I want to be lazy, or I am lazy, or I'm distracted. And that's what I want. I want it to be reflective that way. I'm looking at a drawing right now, and I'm trying to figure out if there *is* a style there. [laughs]

The very first work was the drawing of an already existing cup. Now it's the cups I make that become the subject matter that I choose to draw. But I also choose to draw other things. I don't limit it to the cup. It's whatever I'm interested in at the time. I also make a lot of photographs. I think for the last few years I've really been photographing more than I've been drawing.

You were photographing the cups almost immediately, weren't you?

Yeah. Not in the sixties when I was in art school. But as soon as I started getting into 3-D, they became a subject matter, because the cup was waiting for something to happen. I had this feeling that it was always there and it was just one of those things that you just kind of gravitate to until the idea overcomes you. It was always out there, but I never had the big, conscious step. It was just a series of things that eventually led me down that road. I never thought, 'oh, this could be the metaphor.' It wasn't that way. But as it grew, once it went to the first drawing, it kind of satisfied that thing that I had noticed earlier about that handle that was put on crooked. So then the next one

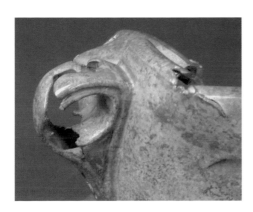
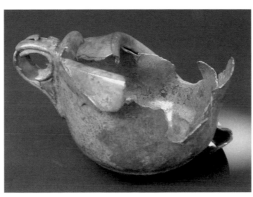

◀ ◀
Surrounded, *1990*
Bronze
5 1/2 x 8 1/2 x 6 3/4"

and the next one and the next one. And then once I did that drawing of the Roy Lichtenstein cup, the idea became much more formal and less neurotic. It had to do with him, not me. Then it became a formal exercise: can I draw it in 3-D, all those band-aid dots? [laughs] So I think *that* was the drawing that really put me into another way of thinking, that expanded my way of thinking about it.

◄ ◄ ◄ ► ► ►

Let's talk about the bronze cups. They're not transparent, they're not fragile; in many ways they are the antithesis of the porcelain cups. Does the relative permanence of the bronze change the underlying conceptualization of your intent about the cups?

With bronze, because I am working with the wax, the wax allows me to play with it. When I do the bronzes, I know that I can make the object screwed up exactly the way I want it. That is the big difference, and that's what is so great about the bronze. The wax allows me to manipulate it: you can play with it, you can leave it, you can go to dinner, you can let it sit there a week or a month, and you can come back and screw with it some more, and you can change it again. The wax allows me to really have certainty, which I didn't have with the clay at all.

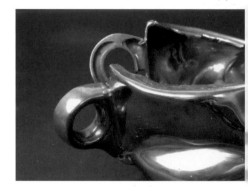

In addition, I was interested in reflection with the bronzes, rather than transmission of light like with the porcelains. The bronzes reflect light, so that was playing with the opposite, and you can anticipate how it's going to reflect. I had conceived very early on of doing a cup in silver, but I didn't know how to do it. I didn't have the access or the money to get that made. In a way I'm kind of glad I didn't, because it wasn't the right object for it. What I liked about the idea of silver was that you could polish parts of it and let it go dull. Another was the idea of an enamel coating that you could put over something. Or doing a cloisonné piece that would be partially broken instead of so formal and so clean, like you'd usually see in cloisonné. You'd have a broken piece, with part of it metal and part of it enamel; part of it would be dull and part of it would be shiny. I'm interested in that, in metal, so when I started doing the waxes I was able to pull it off, although I haven't been able to do the enamel yet. Plating also interests me. You could take silver and plate it with copper, and then sand it back, that kind of thing.

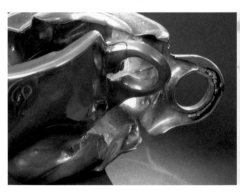

When and where did you start the bronze cups?

I did my first ones at Anderson Ranch, in Aspen. I don't think I was able to do bronzes until '90 or '91. They were setting up the bronze casting facility, and I made waxes, and then went out to Colorado and cast them.

So you made the waxes in your [New York] studio?

Yeah. From the same mold [as I used for the porcelain cups]. And then I did a teapot as well. But then I got into the reflective thing. Bronze still interests me, because you can manipulate the wax a lot, and with the bronze you can really make your intent known. You can't do that with clay.

Gemini, 1990
Bronze
3 1/4 x 7 1/2 x 4 1/4"
Collection Geanne Finney
New York, NY

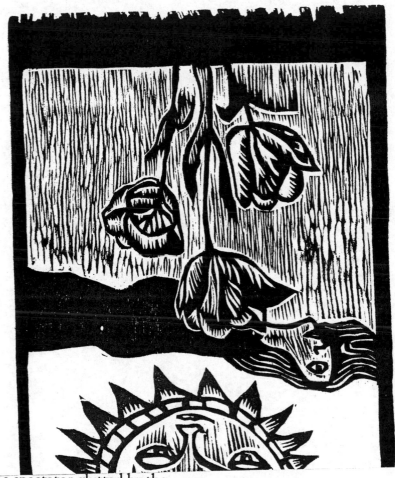

...seworthy, attracting the spectator glutted by the
...prehensible, ever more in need of a sanitation of images
... practice of a certain visual ecology.

...Traba
...American Art Historian
...er, 1980

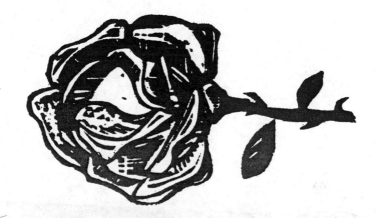

So you're really exploring different ideas via the different media, as opposed to simply seeing how the same concept could or would translate into different media?

Right. And also, different ways of *seeing* them. The bronzes are really made to be photographed. When I photograph them, I use only the ambient light that is coming into the studio. Some of those exposures are fifty minutes or an hour, using only the street lights that come in. Then I take little silver cards and put them around the piece, trying to move the ambient light into the reflection. When I focus the camera, which is done with a 4 x 5, I have to turn the lights on just to see the piece. And once I see it, it's hard to take an exposure reading, so I guess at it, and then I have to develop the film differently. It's all about reflection. It's like the sculpture of Medardo Rosso, the Italian sculptor who was from roughly the same period as Rodin. He would take plaster and then cover it with wax, and then when the light hit it, it would glow. That was his idea: it would become luminescent because the wax would pick up the light. It wouldn't bounce off, it would go in, whereas with bronze it bounces off. So when I'm working with bronze I'm thinking about reflection. When I photograph them, I'm showing you how I see them.

And these cups don't have a connection to the idea of hearing stories?

No, they're much more formal kinds of pieces.

◄ ◄ ◄ ► ► ►

What has been the influence of your own personal cup collection? Did your collecting immediately start with that first University of Washington cup, continuing without stop, or was it something that grew gradually?

Gradual growth. I picked up a few pieces. When I was at the University of Washington we had a great Salvation Army in Seattle, and I would pick them up. Howard was collecting things, and other graduate students were collecting different things, and so I started on the restaurant cup, because of that handle on that one cup. Howard was into deco, and other people were collecting other things. Some of the people that I went to school with were collecting smiley-face pieces, you know, things that you could get for nothing. Now, I see these same cups going for fifty or sixty dollars, and I can't believe it.

You seem to be more aggressively – proactively – searching out special cups, perhaps in contrast to the serendipitous "find" of earlier years?

Right. Yeah. I had this little addiction to Ebay for a while, and that's sort of over, thank god. It was too expensive and too much record-keeping. But I learned a lot, and I'm still interested, and when I go around the flea markets, I'm still interested. Now, what I go for are designer pieces, how they interpreted things. I've been collecting teapots and cups, but not as aggressively any more because now I realize I'm overwhelmed. I've got too many things, now, and no place to put them. But every time I see something I really like, I get it, especially if the price is right.

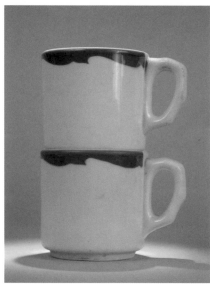

Selections from the Cup Collection, 2002
New York, NY

Living with these factory-produced objects has really changed your aesthetic, hasn't it?

My collection really has to do with differences and the same. That you have the same cup done by five different manufacturers interests me. The slight differences on the same thing, that a lot of people don't see. So I've been trying to make little typology kinds of statements. I have some TWA cups, for example, one is made by Rosenthal, others by different factories around the world, making the same piece. People recognize it, whereas before it was just the shape that interested me. I have two American Airlines cups, and when I started teaching industrial design at Pratt, I had to go to a luncheon and this senior faculty member was sitting across from me. I tried to make conversation, and of course I knew that everybody [at that luncheon] went to Pratt, so I said 'Did you ever study with Eva Zeisel,' and she said yeah, she worked as a tableware designer for a while, and that she had designed some pieces for American Airlines. And all of a sudden I said, 'You didn't design a first-class cabin cup for American Airlines in about 1972, with the D-shaped handle?' And she said, 'Yeah, I designed those pieces.' And I said, 'I have two of them in my collection.' So the anonymous piece became not so anonymous! It blew her away, and it blew me away, too. What's interesting to me is who designed these pieces to begin with, who put them into our culture?

Does knowing that answer change your relationship to them in any way?

Who knows? I'm sure it has some effect. I don't think about it too much. It's just curious to me, why different cultures drink out of different shapes. I think that the cup is the most basic thing, too. That's what I like about it. It's the most basic kind of shape, and useful. And the whole concept of taking clay, and in a more formal way, the amount of technology and thought that goes behind the teacup. (That's the other thing that's written about my things that I don't like, they say they're teacups, but they're really coffee cups.) The whole industrial generic diner thing interests me. That's what I was saying about art and design, that the boundaries are just beginning to break down. We're just at the very, very beginnings of it. And the other thing is that because I have a background in clay, I know what I'm looking at, whereas a lot of these designers don't have any notion of what's really going on. Like Eva Zeisel, for instance, she has no real idea about how they glaze it, how they put the handle on; she has no idea of what's really involved. She just knows it's done, and she knows what effect she wants. She doesn't really have that kind of education in clay. But you put somebody like me in the factory, and I'm going to go in and figure out how it's done. I'm not going to reproduce the machine, but I'm going to figure out how it's done and then how to play with it.

◁ ◁ ◁ ▷ ▷ ▷

When you started working with the cup, you didn't think about doing so many, over so many years.

No, I had no notion I was going to be married to the cup. It's true, though, because every time I started again, I'd think, 'Jesus Christ, I can't believe that I'm doing this thing again.' But now, I've got other ideas. You know, the capsule interests me, and the teardrop interests me. The teardrop is basically what I'm interested in at the moment. The lava lamp interests me. Just pure abstract pourings of clay interests me. There're a lot of other things that interest me now. It gets back to that question of the humble.

The cup has moved to a different place, and is now a symbol of something that people recognize more as an art object. I don't do it because of that, but I see that it has more effect on people than it did in the past. Who doesn't like a great, gigantic teardrop, you know? But I don't see [the teardrop] the same way. It's not really part of my life; I don't have the same connection to it. When I think about drawing something, I don't think about drawing many other things [besides cups]. I can see the drawings going on for a lot longer than the cups, actually. The drawings might be like Morandi, except he was working much more formally, with composition. I don't know if I'll be that formal. But the [cups] that are more personal to me I've kept, and I can see myself making drawings of them.

You have been exploring this series for over 25 years, and there have been periods in which you've laid it aside. What was the draw that made you return to it again and again?

Good question. Really good question. Although, I think I've come to the end.

Really?

Yeah. I have some other kind of metaphorical ideas now, that do a similar thing in a way, but they transfer the metaphor to a different place. I think I've taken the coffee cup about as far as I could take it. I don't want to say that I'm never going to do another one, but I just don't think that there are that many more out there. Although I'm going to try to do a group of large ones, right now. And that's about it. I can't really think about doing many more. But who knows?

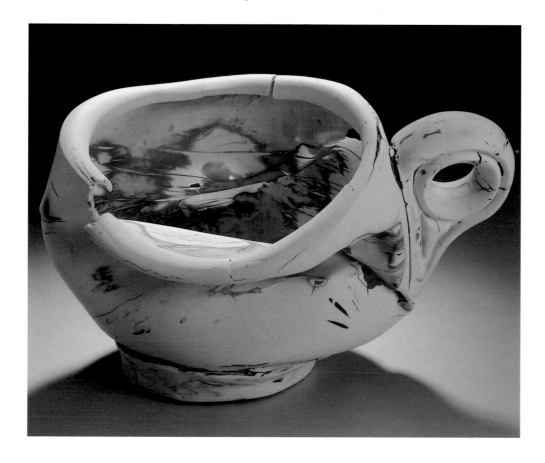

Roger, 1986
Porcelain
9 5/8 x 15 x 9 1/4"
Collection of Dorothy and George Saxe
Promised bequest to the Fine Arts Museums of San Francisco

MARCH 4

MARCH 25

March 25

Mo

h 24

MARCH 4

MARCH 4 + 17

Feb 19

March 26

MARCH 18

Tape tore this
square. I lost
interest quickly
because of the
accident

Spill water on this
square and got
tired of Drawing.

Feb 19

had Fun
drawing this
even though the
pencil was
Darker
than
the square

MARCH 17
#2

Feb 16
wants to be able
to spend time
with this square
lost interest
when I discovered
what I was
with this
square

FEB 26

March

MARCH
18

ANIMISM

Paul Schimmel

Chief Curator, Museum of Contemporary Art
Los Angeles, CA

Irvin Tepper's ceramic cups and intensely rendered drawings are alive and endowed with feelings. Tepper's drawings of porcelain cups relate by way of narrative texts the story the cup has observed. These texts ascribe human and animated qualities to the artist's cups. The cups are endowed with reason and individual spirit. In short, they are animistic. These cups speak of the human condition and act out an emotional reality through melodrama. At times, they offer moralistic stories. At other times they adopt a sarcastic tone.

Throughout Tepper's career, he has relished the power of an object to express experience. Tepper allows the object to reveal its story in various ways. His drawings of porcelain cups instruct by way of extensive text. His ceramics unveil their secrets in a purely visual manner.

Tepper's first experience in object making came as an undergraduate at the Kansas City Art Institute, where he mastered traditional wheel thrown pottery. Under Professor Ken Ferguson he learned to appreciate the oriental tradition whereby perfection is deliberately tempered with a flaw. Tepper had abandoned traditional pottery by the time of his graduate studies at the University of Washington, where he concentrated on ceramic narrative tableaux. These works embraced political and social concerns, sometimes employing found texts or autobiographical references. By the end of graduate school Tepper felt that ceramics was no longer a suitable medium for his concerns. He utilized photography as the primary medium for his increasingly conceptual work.

Tepper became involved in the San Francisco conceptual art world in 1971. Conversations with Terry Fox and Paul Kos as well as philosopher James Friedman created an intellectual environment that sustained Tepper in his conceptual orientation. He associated as well with the group around the Museum of Conceptual Art. During that time, Tepper investigated a variety of dematerialized approaches to art. He began a long period of exploratory ventures that included video, performance, photographic narrative, and stereoscopic photography. Photography later became a crucial element in the drawings, aiding his rendering of the cups. Between 1974 and 1976, Tepper used stereoscopic photography as a medium whose image existed only in the viewer's mind, not on the picture plane. Video gave Tepper the opportunity to explore real time narration, story telling and humor.

For one video tape, Tepper went on a diet. The diet failed, but the tape was a success. Later in 1974–1975, Tepper actually did lose 100 lbs. and from this experience he saved the belt which recorded the inches lost as added notches.

◄

Idea Drawing for Flawed Cup (detail), *1975*
Graphite on paper
11 x 14"

▼

University of Washington Cup, *1972*
This is the original manufactured cup, pilfered from the University of Washington cafeteria while Tepper was in graduate school, that sparked the conceptualization of the cup series.

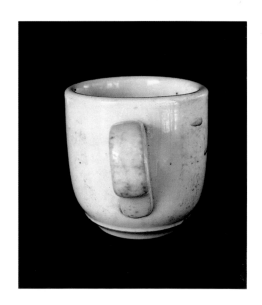

This was the beginning of animism in Tepper's work. At the time that Tepper was physically altering his body for reasons having nothing to do with art, body art as practiced by Dennis Oppenheim, Vito Acconci and Chris Burden was at its height. The documentation of weight loss through an object, the belt, was like a remnant of a performance. Tepper realized that the belt had the ability to tell a story. The life and soul of the artist were reflected in the belt's extra notches. This marked a significant juncture in Tepper's career. Around 1975 he began to be aware of the ability of an object to suggest action, feelings, ideas, history and, especially, generate a powerful phantom presence of persons who either owned or used that object. The belt, while not created as an art piece, performed exactly this narrative function.

Idea Drawing for Flawed Cup, 1975
Graphite on paper
11 x 14"

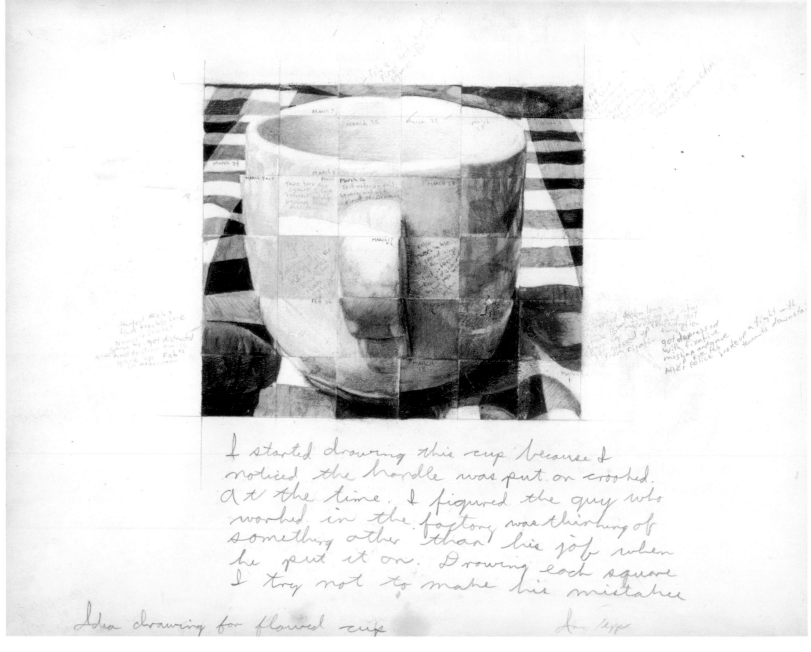

I started drawing this cup because I noticed the handle was put on crooked. At the time, I figured the guy who worked in the factory was thinking of something other than his job when he put it on. Drawing each square I try not to make his mistake.

Tepper's first drawing of a cup, *Idea Drawing for Flawed Cup*, 1975, used this idea of the powerful object. The cup pictured in this drawing had been pilfered from the University of Washington while Tepper was a graduate student. "It was a standard Syracuse china coffee cup. However, it has a crooked handle." And as Tepper has said, "I was excited by this cup because it had an imperfection. It was a machine made product that was not perfect." Like the belt with those notches, the cup, although machine made, was transformed by a human being. Tepper photographed the found cup with a stereo camera, hoping to highlight the imperfection, and thus show the human, fallible element of the process which had manufactured this coffee cup.

Tepper is concerned with beauty that reveals itself at the moment when objects are on the verge of disaster or falling apart. He extracts human qualities from these objects. It was not until 1976 that Tepper made his first mold of this cup and it was at least another year before the first successful porcelain cup was executed. Tepper's technique involves making a cast of the cup, intentionally warping and cracking it, piecing it together and finally sanding it until it is paper thin. "I wanted it to look really old, like it was the cup's last cup of coffee, and had just been used up. The cup has to have age, and it has to look like it's been worn down, and has seen something and has lived to tell about it."

All of Tepper's cups have been cast [*n.b*: as of this writing, 1983] from either this mold or an enlarged version of the same shape which he realized in 1981. He developed a technique of pouring alternating layers of colored (usually black and white) porcelain which after delicate sanding become translucent and reveal abstract forms between the cups' layers.

The cups' ability to capture and play with light animates them. Their appearances are malleable and are greatly influenced by their environment. These cups must have an animistic presence to succeed – they must rival the presence of objects that have withstood years of experience. They communicate more immediately, but in a more abstract fashion than do Tepper's drawings, and demonstrate Tepper's renewed belief in the eloquence of a traditional art object.

Tepper's first drawing, *Idea Drawing for Flawed Cup*, was intended as an exercise for himself. This drawing brought together the disparate elements of his earlier art: ceramics, narrative, and an awareness of process. In *Idea Drawing for Flawed Cup*, Tepper's interest in the cup's genesis is related in the first person narrative: "I started this drawing because I noticed the handle was put on crooked. At that time I figured that the guy who worked in the factory was thinking of something other than his job when he put it on. Drawing each square I tried not to make his mistakes."† Tepper used a grid in this drawing, deliberately covering all squares adjacent to the one he was drawing. This produced a deliberately skewed representation, turning an academic technique into a means of heightening the presence of the drawing as an object.

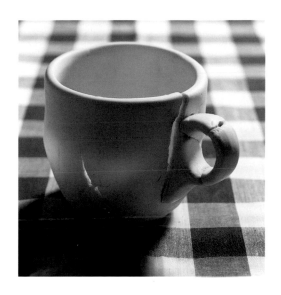

First Cup, *1977*
Porcelain
3 x 4 3/4" x 3 1/4"

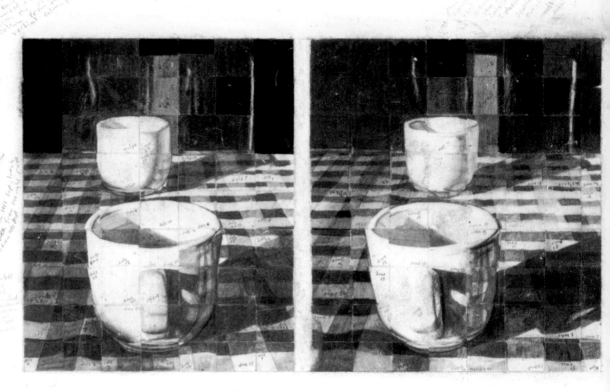

This story isn't finished yet. A conversation is supposed to take place. Having coffee presents a neutral setting, but the conversation remains at the level of the setting. The cup closest to the viewer has a flaw in the handle. It has been put on the cup crooked. Placing myself exactly in the middle of the cup, I close my right eye and then my left, trying to straighten the handle out.

Tepper's adoption of the grid was influenced not only by its currency in other art, but by the fact that his girlfriend at that time was a professional restorer of rugs and quilts. The diaristic notations in and around the drawing concentrate on personal events which distracted the artist and are used both as an apology for, and to focus attention on, the formal imperfection of the drawing.

This drawing was drawn in a notebook. Tepper created small notebook drawings from 1975–77. In 1977 he began to draw on a larger scale on a drawing table, with exhibition in mind. Since 1980 he has also created large scale wall drawings, sometimes composed of multiple panels.

In retrospect, Tepper's adoption of written narrative in 1975 is not surprising. Many artists in the mid 70s, from such diverse backgrounds as the linguistic orientation of Baldessari and the psychological orientation of Acconci, adopted narratives in their work in conjunction with visual imagery. Tepper at the time was reading widely, and found confirmation for his ideas in the novels of William Burroughs, Louis Ferdinand Celine, and in Alain Robbe-Grillet's *Jealousy*. The anxiety that pervades these writers' texts is a major theme in Tepper's drawings. This sense of anxiety and tension has influenced the rough look of the drawings themselves, and has the inspiration of such non-object-oriented artists as Duchamp.

Many of the formal elements of the *Idea Drawing* have remained constant in Tepper's art. The use of the grid has been superseded by dividing the drawing into concentric circles. Tepper still draws each area without reference to adjacent areas, allowing greater concentration and expressing the discrete moment at which the area was drawn. He aims to create not an optically unified image, but a cohesive one through a fractured evocation of the object. The diaristic notations not only heighten the immediacy of the individual drawn area, but document the slow tedious method by which Tepper draws. In conjunction with the drawings are texts employing a range of voices. Tepper's earliest narratives were impersonal, almost journalistic; first person narratives soon followed; finally came the narratives in which the objects speak.

In the drawing *Confidence Man*, 1978–79, the artist shares the narration with the cup itself. It was Tepper's intention to have the cup be the narrator in order to avoid being directly responsible for what was being said. The object is doing the talking, not the artist. It is as if the cup has been listening to the conversation that has been taking place over it.

In *Confidence Man*, this text appears: " ...unfortunately he lost interest in his product years ago, but has been so dependent on the success of his method he is afraid of giving it up or changing it. His confidence, like the cup, is not all black or all white."† The quote relates to Tepper's rejection of facility, and his recognition of how easy it is to settle into a comfortable groove. He makes clear his rejection of complacency,

This Story Isn't Finished Yet..., *1976*
Graphite on paper
3-D stereo drawing
11 x 14"

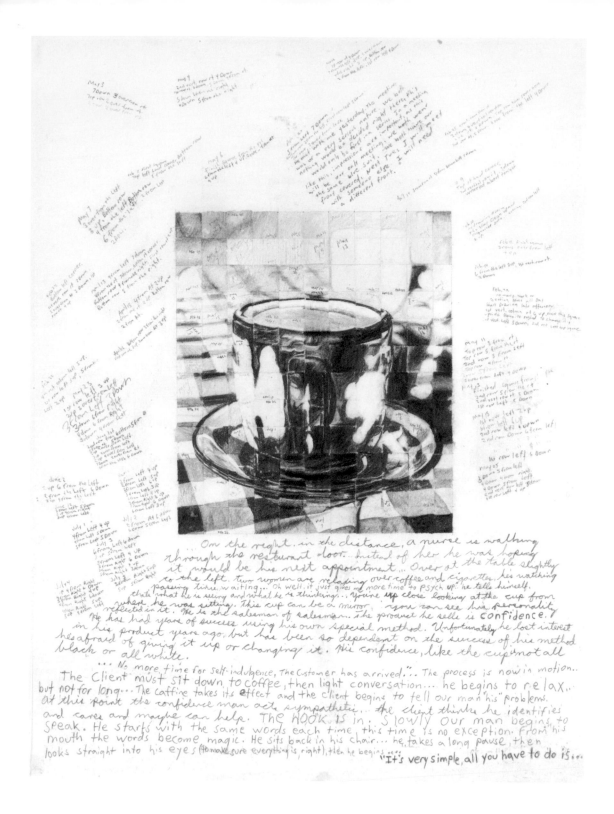

Confidence Man, 1978–79
Graphite on paper
14 x 11"
Collection Kenneth A. Cowin
New York, NY

PART 2

...No more time for self indulgence. The customer has arrived... The process is now in motion...

The client must sit down to coffee, then light conversation... he begins to relax... but not for long...The caffeine takes its effect and the client begins to tell our man "his" problems. At this point the confidence man acts sympathetic...the client thinks he identifies and cares and maybe can help. The Hook is in. Slowly our man begins to speak. He starts with the same words each time, this time is no exception. From his mouth the words become magic. He sits back in his chair... he takes a long pause, then looks straight into his eyes (to make sure everything is right), then he begins... "It's very simple, all you have to do is..."

of slickness, of over-determination, and of comfort. He is laying down his theme of risk taking: allowing things to happen (*e.g.,* drawing without an awareness of the next square), changing one's life, living dangerously (*e.g.,* sanding the cup so thin that it almost breaks). This is present in the text of *Confidence Man,* a philosophy clearly stated.

Although *Hat Magic,* 1979, like *Confidence Man,* and *Complaining Cup,* 1980, can be put into the category of small drawings, *Hat Magic* is on the cusp between notebook drawings and works done with exhibition space in mind. It is drawn on a larger scale. In *Hat Magic,* the same intensity is brought to bear upon the drawing of each individual square as in the smaller drawings. As the scale moves up, the stroke and touch of the artist's application of the graphite are also increased in scale. *Hat Magic* is a summation drawing that does not employ new means, but shows sophistication and confidence on the part of the artist in the use of techniques and ideas developed in the period of 1975–1978.

Hat Magic departs from previous drawings in the extensive use of short stories which are placed upon the image itself. The narrative text is presented in three lengthy chapters underneath the depiction of Tepper's cowboy hat and the original found cup. The hat is used animistically like the cup, having its own power, soul, life and magic. Tepper, as the narrator, discusses the tenuousness of animistic power and his worry that this power may diminish if paid too much attention to. When Tepper wore this hat, people treated him differently. Their perception of Tepper was changed, not merely because he was wearing a different article of clothing that made him appear differently, but because of the aura of the hat. The story goes on to tell of the fragility of this aura. When Tepper decides to block the hat differently, the magic is lost. The spell is broken as with some fetishistic object.

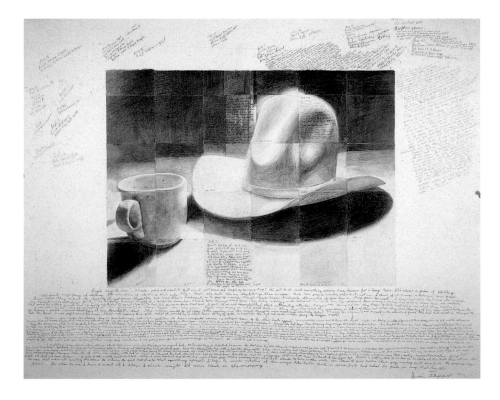

Hat Magic, *1978–79*
Graphite on paper
23 x 30"
Collection Paul and Yvonne Schimmel
Los Angeles, CA

The cup that is pictured in *Heart Cup*, 1978, was cast from the mold of the
original cup. At the time Tepper made this cup he was ending a personal
relationship. As he sanded the cup, heart shapes began to appear within its
layers of colored porcelain. For the first time, one of Tepper's fabricated cups
seemed to generate a powerful, specific emotional presence and dictate what
kind of story it would tell.

The text for the *Heart Cup*, 1979, narrates the story of a friend "whose thoughts
were on a love affair that had ended, never to be regained."† A second story
describes the relationship between Tepper's own experience at that time and
the process of making the cup. In the text, the cup reveals its hearts as he hears
the sorrowful story from his friend. Just as the story deals with disjunction,
so does the drawing. The checkered tablecloth upon which the cup rests does
not line up with the grid of the drawing, creating an especially fractured view.
The representation of cup and tablecloth is further skewed by a large heart shape
which Tepper has arbitrarily laid over the cup. The resulting drawing is extremely
touching, combining strong narrative and visual elements. It is as if Tepper
thrived on adversity, using it to fuel his art.

With *Complaining Cup*, 1980, a narrator tells a story of a conversation between
a mother and daughter who are arguing over a cup of coffee. In the second part of
the text, the narrator changes. It is the cup itself who explains its problems. "I am
the cup and I've got problems too . . . theirs are nothing compared to mine..."†

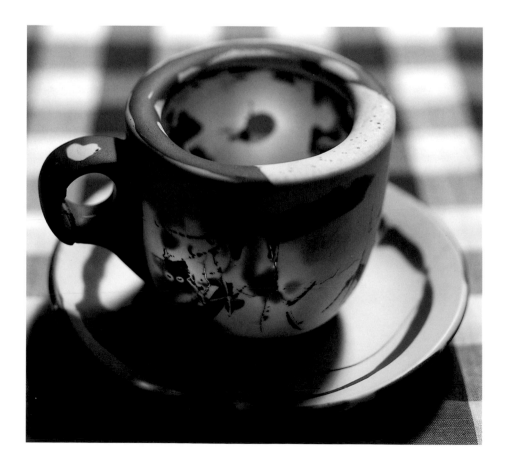

Heart Cup, 1978
Porcelain
3 3/4 x 5 1/4 x 5 1/4"
Collection Joseph L. Parker, Jr.
Tulsa, OK

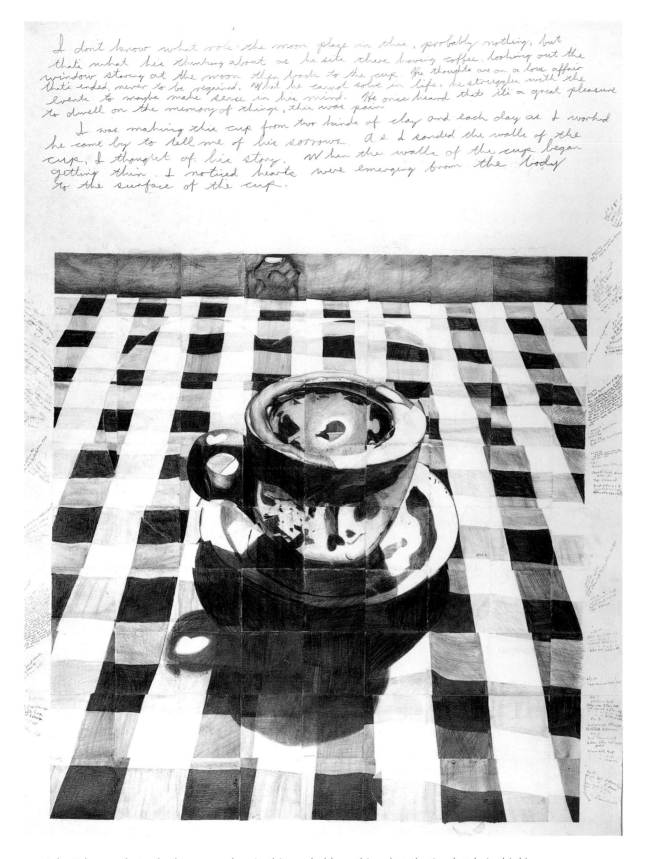

I don't know what role the moon plays in this, probably nothing, but that's what he's thinking about as he sits there having coffee, looking out the window staring at the moon then back to the cup. His thoughts are on a love affair that's ended, never to be regained. What he cannot solve in life, he struggles with the events to maybe make sense in his mind. He once heard that it's a great pleasure to dwell on the memory of things, this was pain.

I was making this cup from two kinds of clay and each day as I worked he came by to tell me of his sorrows. As I sanded the walls of the cup, I thought of his story. When the walls of the cup began getting thin, I noticed hearts were emerging from the body to the surface of the cup.

Heart Cup, 1978
*Graphite on paper
41 1/2 x 29 1/2"
Collection Joseph L. Parker, Jr.
Tulsa, OK*

The cup goes on to tell that he will soon be replaced. The cup's worn and deteriorated condition is not appreciated. Finally, the cup comments upon the artist by saying, "He places me off to the side and slightly off the page and . . ."† The cup feels downgraded, feels merely being used for formal ornamental purposes. He also feels his best side has been left out. In the drawing of the *Complaining Cup*, the left side of the drawing consists of a beautifully patterned, lacy tablecloth. Much to the cup's disdain, the pattern on the tablecloth is given too much prominence. Like so many of the people in Tepper's stories, the cup is discontented and vocal about it.

While Tepper was working on *Why Doesn't It Ring?*, 1980, he was also planning a move to New York. At this time he was also making plans for a one-person exhibition at the St. Louis Art Museum. No doubt the bold shift in scale was accelerated by his realization that it was time to move from a more intimate narrative to larger, more public statements. *Why Doesn't It Ring?* marks a major shift in scale, but not a dramatic change in approach. The image of the telephone is exquisitely rendered, with special care lavished on the coil between the receiver and the instrument box itself. Although the telephone drawing is very large by Tepper's standards, it is rendered in the fastidious technique of his medium-sized drawings. During the process of creating the telephone drawing, Tepper experimented with incorporating words on this new expanded scale. Typographic considerations manifest themselves alongside the larger

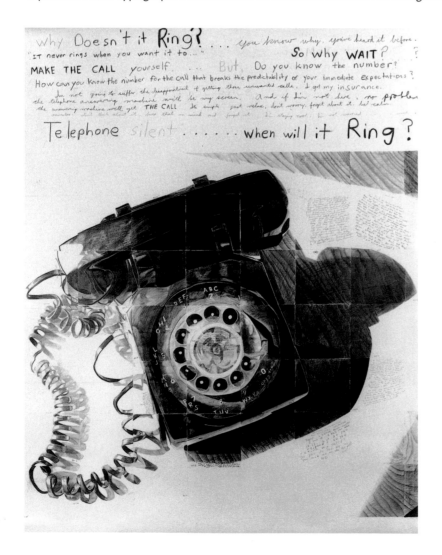

Why Doesn't it Ring...?, 1980
Graphite on paper
71 x 57"
Collection Kenneth A. Cowin
New York, NY

scale of the entire text. The words maintain the stylistically scrawled manner of the diaristic aspects of the drawing. The effect of these words is jarring, however. The steadily diminishing scale of the words is reminiscent of a tabloid newspaper or an eyechart. Tepper's words are no longer a scrawl, but a self-conscious depiction of a scrawl. The text is less intimate, more of a public utterance.

The text itself represents a high point in Tepper's celebration of anxiety as a motivating factor. Tepper demonstrates that a minor aggravation can become an overwhelming psychic obsession. This text, unlike the texts that preceded Hat Magic, was developed by Tepper over a relatively long period of time and was subjected to extensive editing. As Tepper's drawings have become graphically bolder, his texts have become more incisive.

Tepper's drawing *Big Ear or Big Mouth*, 1981–82, again depicts a coffee cup but in a radically new fashion. The work is extremely large, composed of four separate pieces of paper, uses concentric circles rather than a grid, and features a more gestural drawing approach utilizing white charcoal on black paper. Tepper drew the cup as if he were viewing it from above, giving the cup the appearance of a big ear listening or a big mouth speaking. This point of view, combined with the concentric circles, gives this drawing a mandala-like graphic quality. As this drawing is borderless, the texts are interspersed throughout the image. They are conversational in tone, as if casually passing over the morning's first cup of coffee. The matter of fact nature of these texts contrasts greatly with Tepper's next drawing, *He Is Thinking…"I'll get even, just wait!"*, 1982. The drama Tepper sets up in the text begins with purported calmness, distance from problems, and freedom from restraint. This is juxtaposed with the final line that dispels all notions of tranquility. "…A smile begins to appear on his face… He is thinking…I'll get even …just wait!"† This is the false calm created by the prospect of revenge rather than that of harmony with life.

Tepper, like many artists today, is not aligned to any one medium. His allegiance is to concepts and to the cross-fertilization that results from working in many media. He endows his creations with a powerful presence, the presence that results from an object having borne witness through time. His best creations become animistic, like his best subject matter. They are full of experience, not empty perfection. "In the process of making art I like to know my mistakes as well as my successes. If my art is too perfect, then the viewer is missing a lot of experience, a lot of life, like if you shut out the world to reach a goal. My idea of powerful art would be a book that was about someone contracting a disease, which would give the reader the disease and make him die. Art should have that kind of powerful effect."

All quotes are taken from an interview between the author and Irvin Tepper on February 26, 1983

This essay first appeared in the 1983 catalogue *Irvin Tepper: Cups, Drawings, Stories*, Newport Harbor Art Museum, and is reprinted here courtesy of the author. The author wishes to express his thanks to Marc Freidus for his assistance in the preparation of his essay. The author further wishes to express his thanks to Irv Tepper for his generosity and willingness to be interviewed.

† Text from drawings.

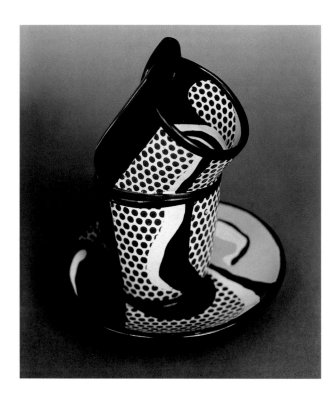

▲

Roy Lichtenstein (American, 1923–1997)
Ceramic Sculpture 3, *1965*
Glazed ceramic
7" high
Photograph Courtesy the Estate of Roy Lichtenstein

"You know Dorothy, Don't you?" that's how he starts our conversation. I don't know who Dorothy is? I think he is trying to find out how much I know about him, which is very little, at the moment. The setting is a suite of offices in a large office building located in the financial district. Examples by well known pop artists on the wall, Warhol, Lichtenstein, etc., standard office furniture and carpet. My cover is that of a photographer whose job it is to photograph this cup for an exhibition catalogue. He won't lend the cup to the show "afraid of breakage" he won't even let it out of the conference room it is displayed in. Photographic gear and lights all set up for the shot...

...THIS IS THE BEST CUP. I picked it out from all the work, This Is The Best One!"... "it is a good one," I say, at the same time wondering if he is suffering from the collectors disease. THE BEST EXAMPLE (TBE)...

"I used to date Dorothy when I would go to New York." "I didn't know that Roy was dating her at the same Time"... "What's she doing now?" I ask – "Roy and her are married." – "So Roy got Dorothy, huh?"... When I drew this cup, at different times, I thought about this story.

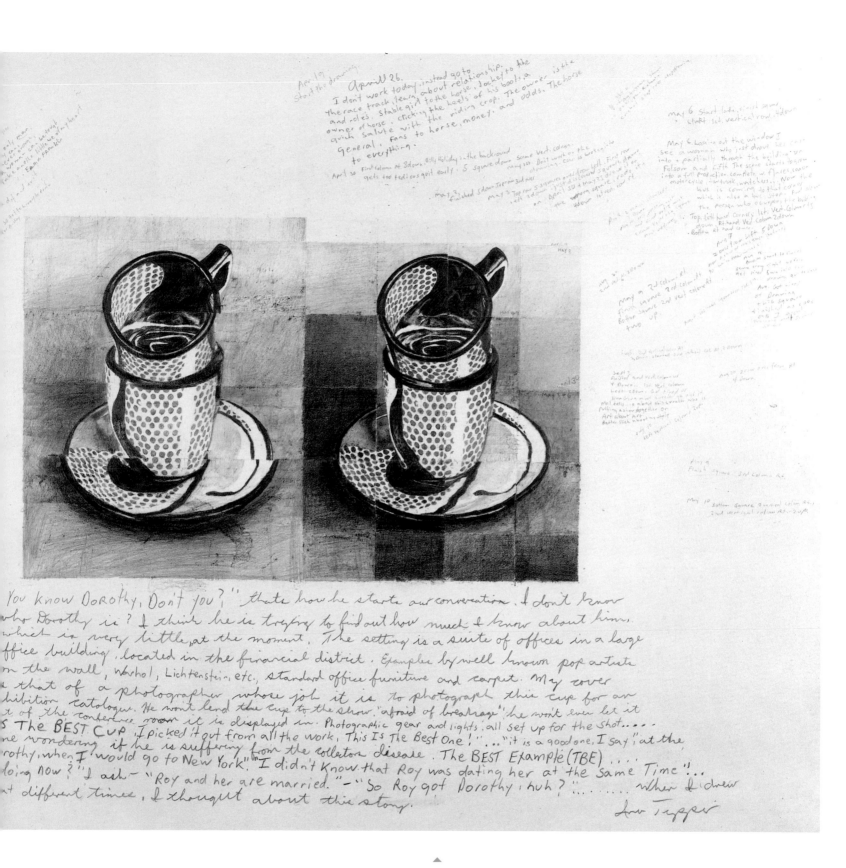

You Know Dorothy, Don't You?, 1977
Graphite on paper
3-D stereo drawing
11 x 14"
Courtesy Museum of Contemporary Art
Los Angeles, CA 94.16
Purchased with funds provided by Dan and Jeanne Fauci

▶
Complaining Cup, 1979
Graphite and charcoal on paper
23 x 30"
Collection Dan and Jeanne Fauci
Los Angeles, CA

"... Now, tell me again, How did you get your hair to stand straight out from your head like that? Let me see if I got it right, you said, you put wires on your hair and then plug the wires into the wall? right? Really, I don't know why you would want to do that to yourself. Your hair is so nice, why would you want to do that, why would you want to change?"

"Mother, I'm not going to argue with you, I keep telling you over and over again, but you don't listen. I am my own person. I'm not your little girl anymore, I can do whatever I want to my hair ... and besides, I don't plug my head in a wall socket, I attach the wires to an electric brain stimulator. Believe me Mother when I tell you, I haven't felt so relaxed... how can I describe it, when my hair sticks out, I feel I can just take the unwanted stimuli and shoot it right out my head, Mother, do you understand what I mean?" "Well, I'm sorry dear, I can't accept that, I think it's crazy to do that to yourself. I think you should..."

I can't believe it, it's not even mid-morning and that's my second mother/daughter argument so far today. I should have known it would be that kind of day. It started off bad enough already... this girl wants to break-up with her boyfriend, she decides it might be easier to do "over coffee," that conversation was number 621 of love/breakups I've been caught in the middle of... I'm the cup and I've got problems too... Theirs are nothing in comparison to mine... Let me tell you what problems are. The restaurant's, where I work, owner is taking his son into the business. His son wants to "have coffee" and talk a few things over with his father... and what do you think he wants to talk over? Me, that's what. The son says . . . "We need new china, this stuff is old and worn out." then he holds me up to illustrate his point. "Take this cup, for example, look how worn out it looks, and these CRACKS! Why it's practically useless!" What does he know, I do my job. I've been caught in the middle of 1251 mother/daughter arguments, what's he done? Tepper, the artist does this drawing of me. He places me off to the side and slightly off to the page. He tells people it's to symbolize how the cup is taken for granted. It's true, he's right but he leaves out my best side and ...

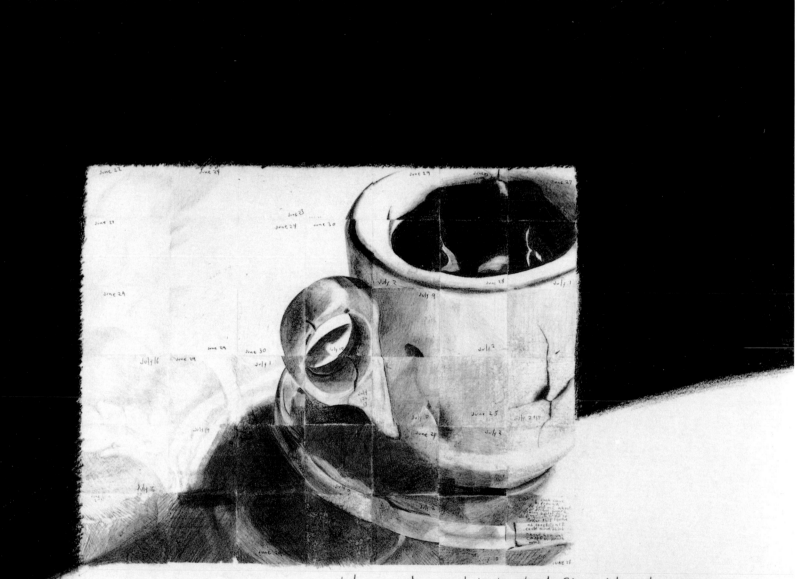

"... Now, tell me again, How did you get your hair to stand straight out from your head like that? Let me see if I got it right, you said, you put wires on your hair and then plug the wires into the wall? right? Really, I don't know why you would want to do that to yourself. your hair is so nice, why would you want to do that, why would you want to change?"

"mother, I'm not going to argue with you, I keep telling you over and over again, but you don't listen, I am my own person, I'm not your little girl anymore, I can do whatever I want to my hair, ...and besides, I don't plug my head in a wall socket, I attach the wires to an electric brain stimulator. Believe me Mother when I tell you I haven't felt so relaxed... how can I describe it, when my hair sticks out. I feel I can take the unwanted stimuli and shoot it right out my head, Mother, do you understand what I mean?" "Well, sorry dear. I can't accept that. I think it's crazy to do that to yourself. I think you should..."

I can't believe it, its not even mid-morning and thats my second mother/daughter argument for to-day. I should have known it would be that kind of day, It started off bad already... this girl wants to break-up with her boyfriend, she decided it might be easier to do "over coffee", that conversation was number 621 of love/breakups I've been caught in the middle of... I'm the cup, and I've got problems too... their are nothing in comparison Let me tell you what problems are. The restaurants, where I work, owner is taking his son into the business. His son wants to "have coffee" and talk a few things over with his father... and do you think he wants to talk over? me thats what the son says... we need new china, old and worn out, then he holds me up to illustrate his point, "Take this cup for example, look how worn out these cracks! why its practically useless!" what does he know, I do my job, I've been caught in the middle of 1251 mother/daughter arguments, whats he done? Flipper the artist does this drawing on the side and slightly off to the page. He tells people, its to symbolize how the cup is taken for granted, its true, his right, but he leaves out my best side, and

Complaining Cup, 1980
Porcelain
3 3/4 x 5 x 5"
Collection Dan and Jeanne Fauci
Los Angeles, CA
(Destroyed)

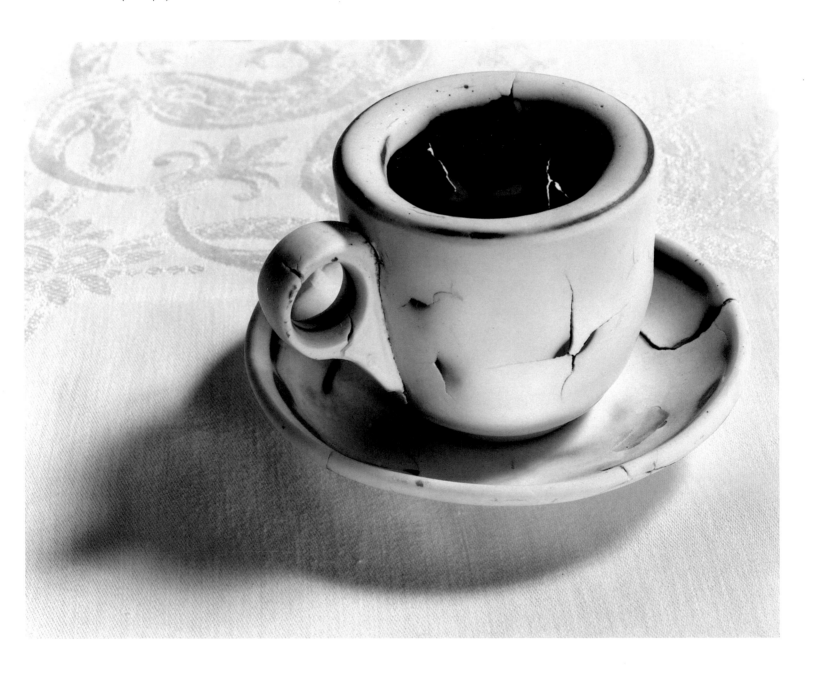

Still Complaining Cup, 2001
Porcelain
3 3/4 x 5 x 5"
Collection Dan and Jeanne Fauci
Los Angeles, CA
*(**Complaining Cup** restored)*

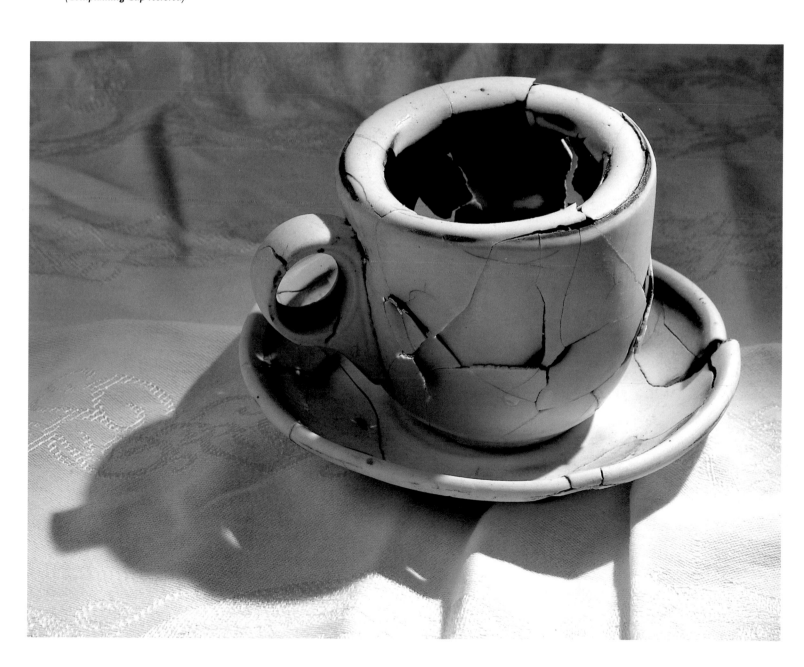

Annie's Cup, *1979*
Porcelain
3 3/4 x 5 x 5"
Collection Annie Gerber
Seattle, WA

Annie's Drawing, *1982*
Graphite on paper
42 x 32"
Collection Annie Gerber
Seattle, WA

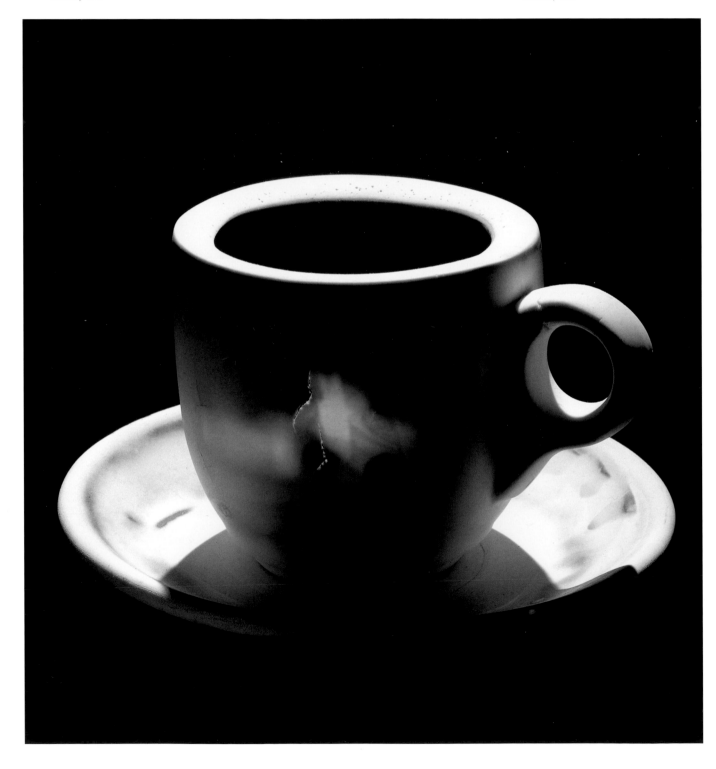

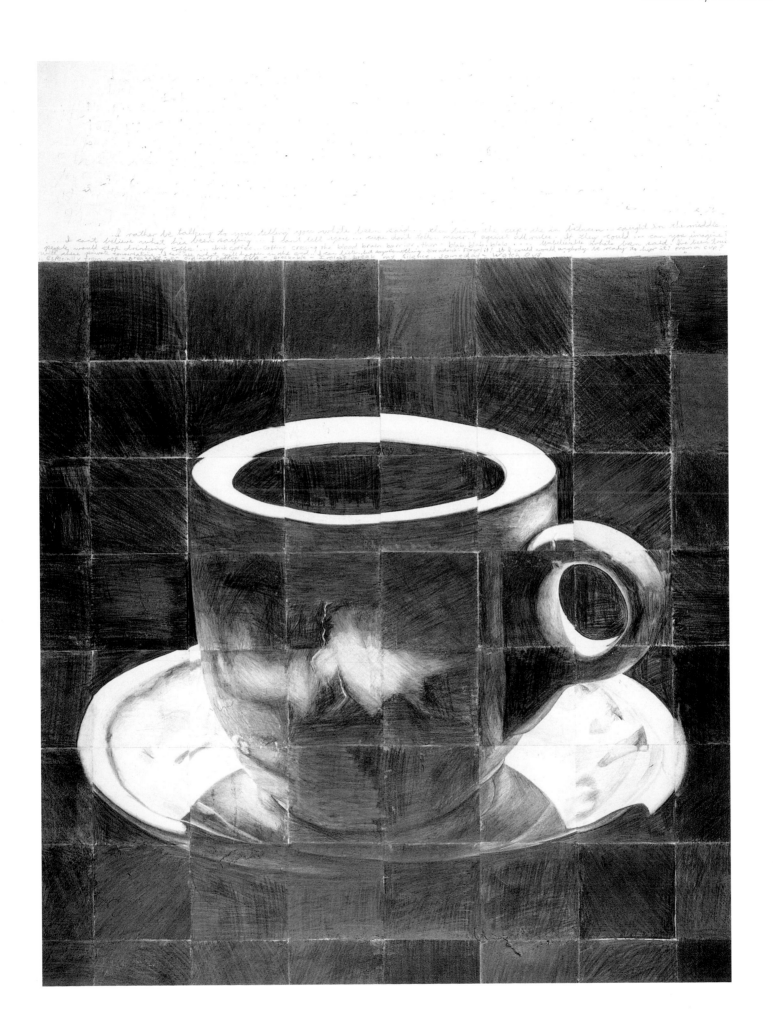

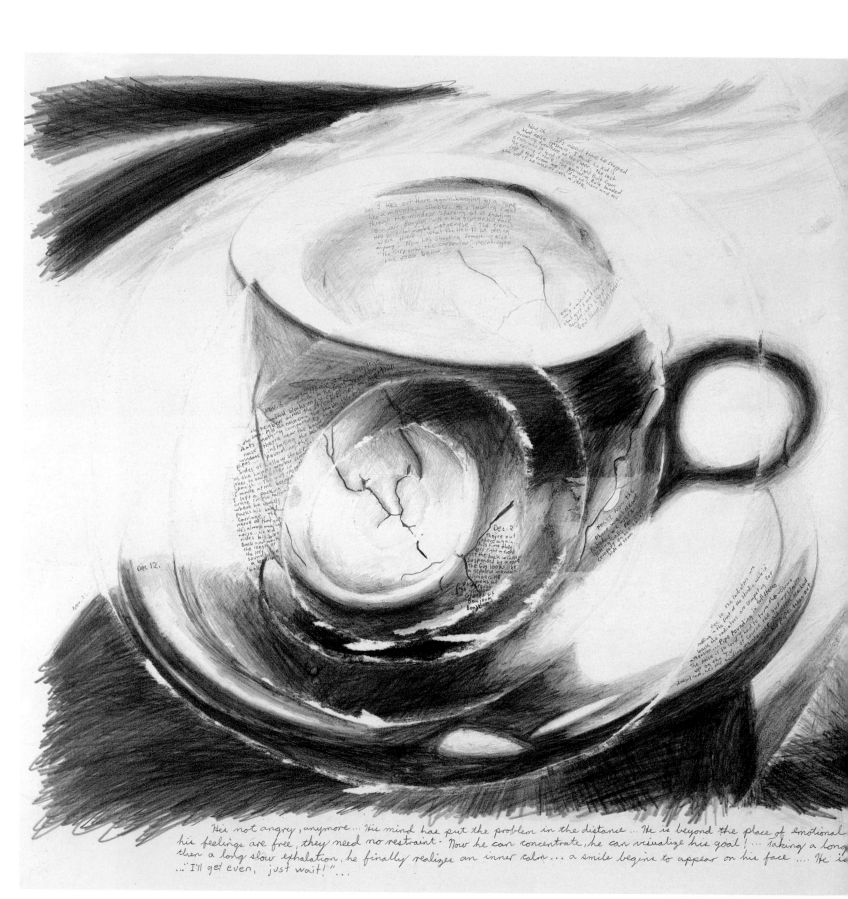

"He's not angry, anymore ... His mind had put the problem in the distance ... He is beyond the place of emotional vulnerability ... his feelings are free, they need no restraint – Now he can concentrate, he can visualize his goal! Take a long deep breath, then a long slow exhalation, he finally realizes an inner calm... a smile begins to appear on his face ... He is thinking ... "I'll get even, just wait!"...

◄

He Is Thinking..."I'll get even, just wait!", 1983
Graphite on paper
23 x 30"
Collection Stephens Incorporated
Little Rock, AR

▼

He Is Thinking..."I'll get even, just walt!", 1982
Porcelain
3 3/4 x 5 x 5"
Collection Ben Liberty
New York, NY

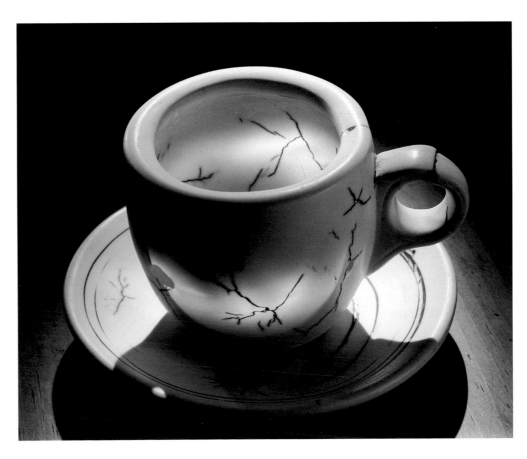

▶

***It's the Busy, Worrying Mind that Keeps Us
 from Acting with Animal Grace,*** *1983*
Graphite on paper
42 x 32"
Private Collection
Berkeley, CA

▼

***It's the Busy, Worrying Mind that Keeps Us
 from Acting with Animal Grace,*** *1984*
Porcelain
5 1/2 x 8 x 8"

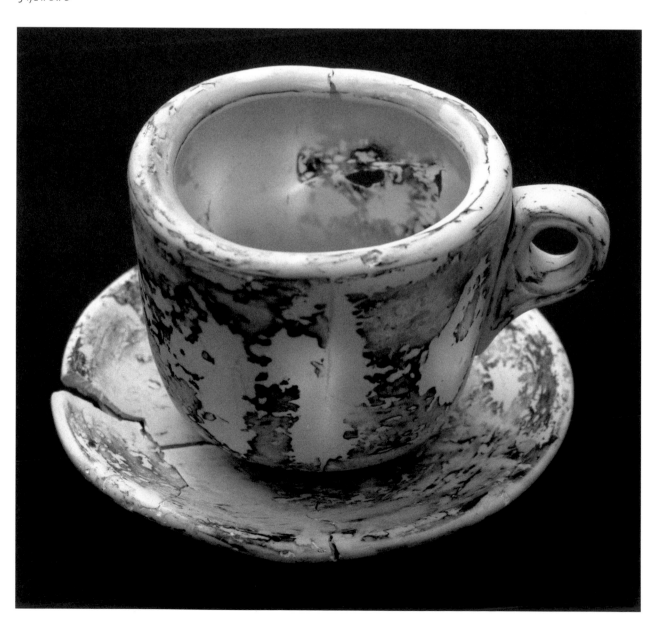

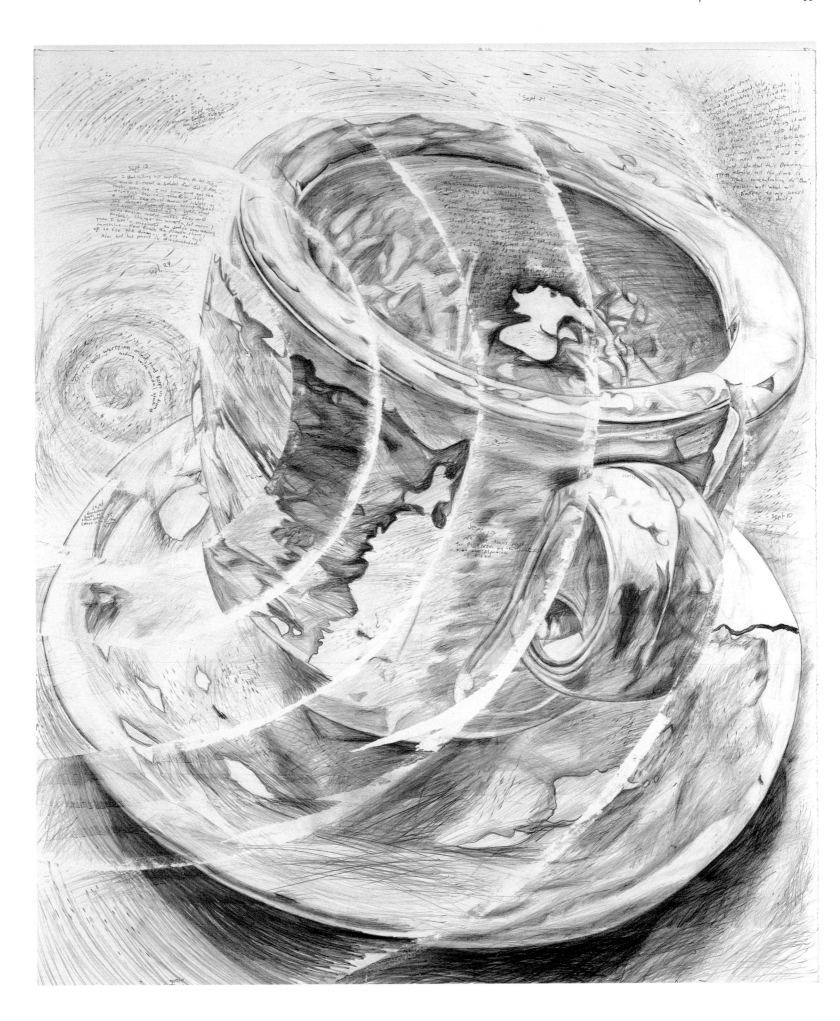

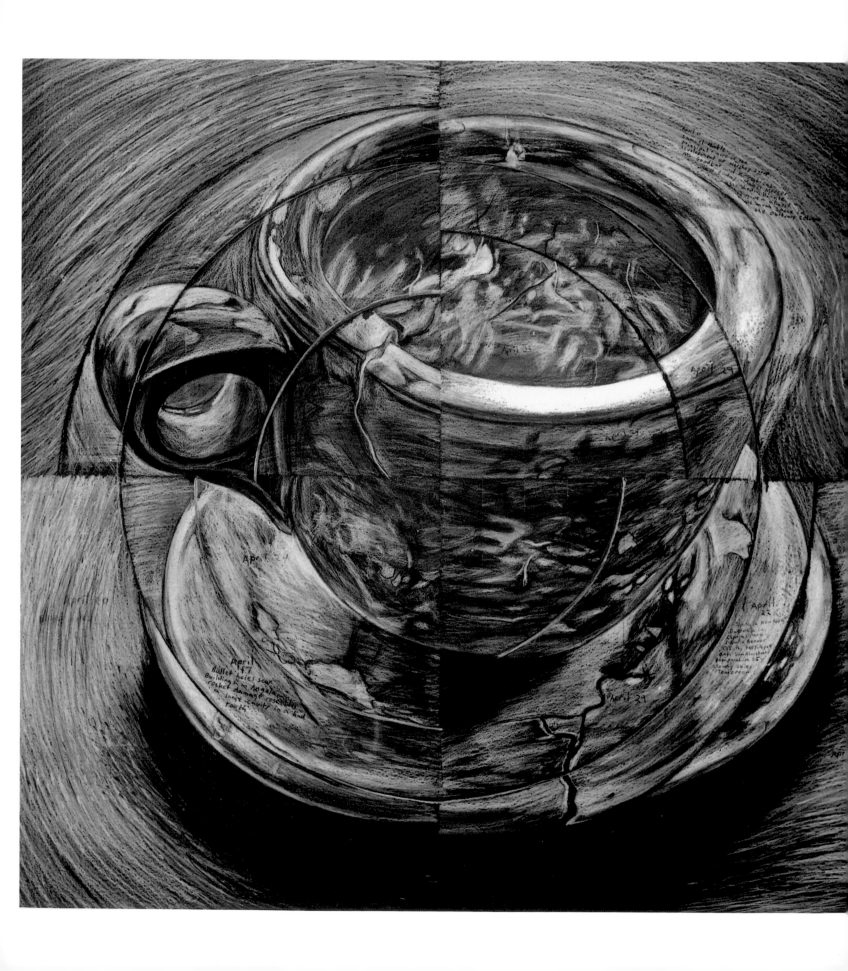

◄

Towards the Moment of Tranquility, *1983*
Charcoal on museum board
32 x 32"
Collection Samuel Stebbins
Redwood City, CA

▼

Towards the Moment of Tranquility, *1983*
Porcelain
5 1/2 x 8 x 8"
Collection Samuel Stebbins
Redwood City, CA

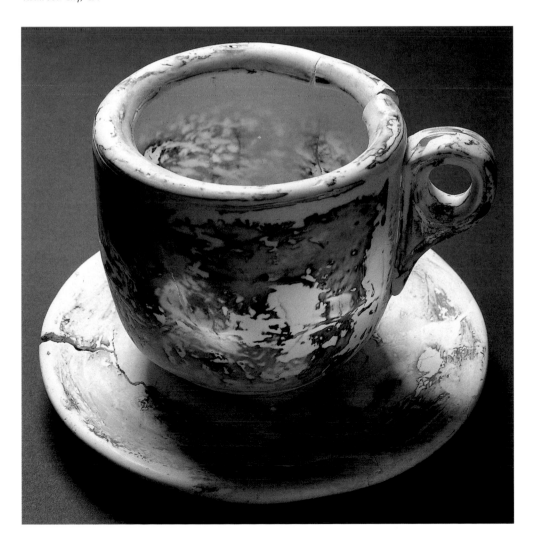

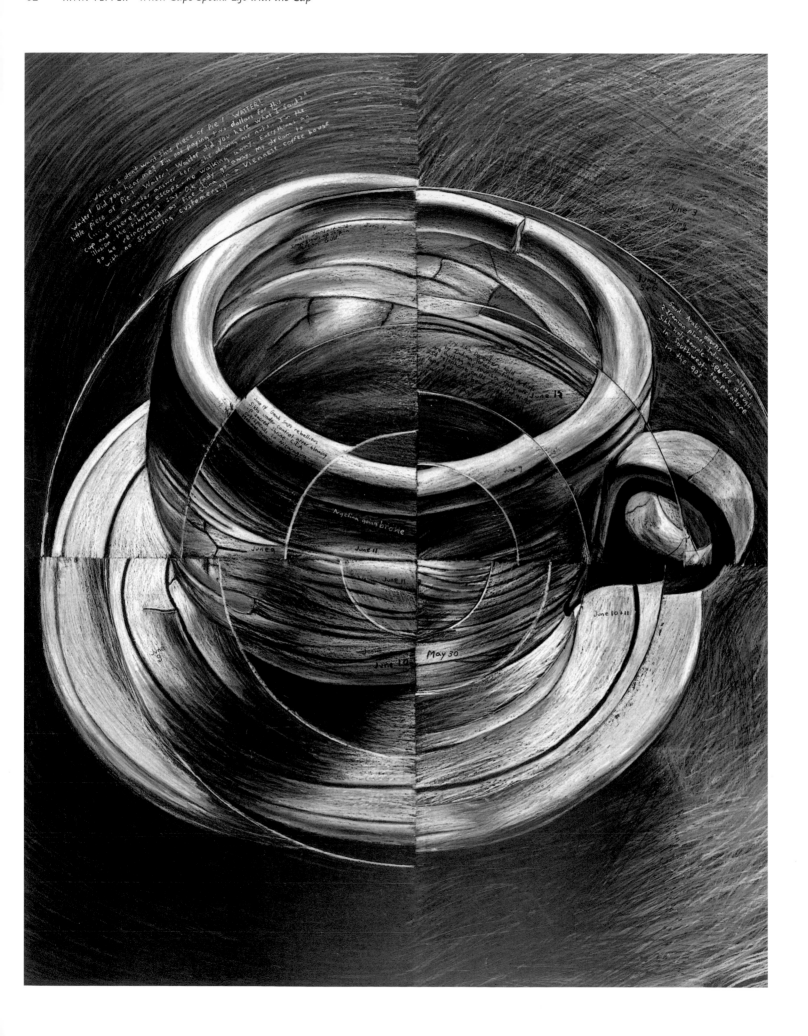

It's Their Problem Not Mine, *1984*
Pastel on museum board
40 x 32"
Collection Joseph Scalzo
Washington Depot, CT

C-6, *1983*
Porcelain
5 1/2 x 8 x 8"

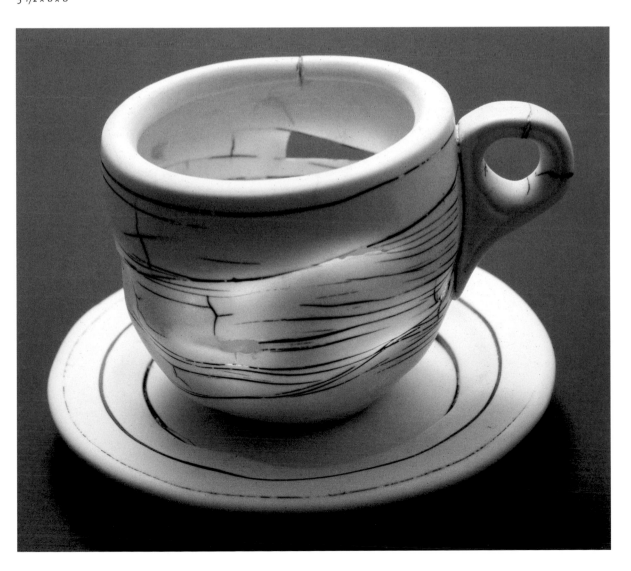

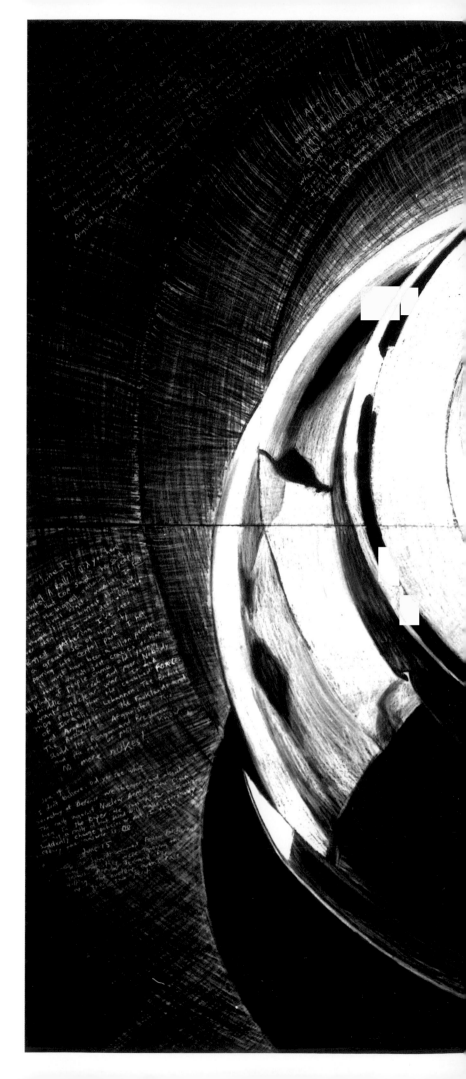

Big Ear or Big Mouth, *1982–3*
White charcoal on black museum board
64 x 80" (including four panels @ 32 x 40")
Collection Orange County Museum of Art
Newport Beach, CA
Museum purchase 1983.008

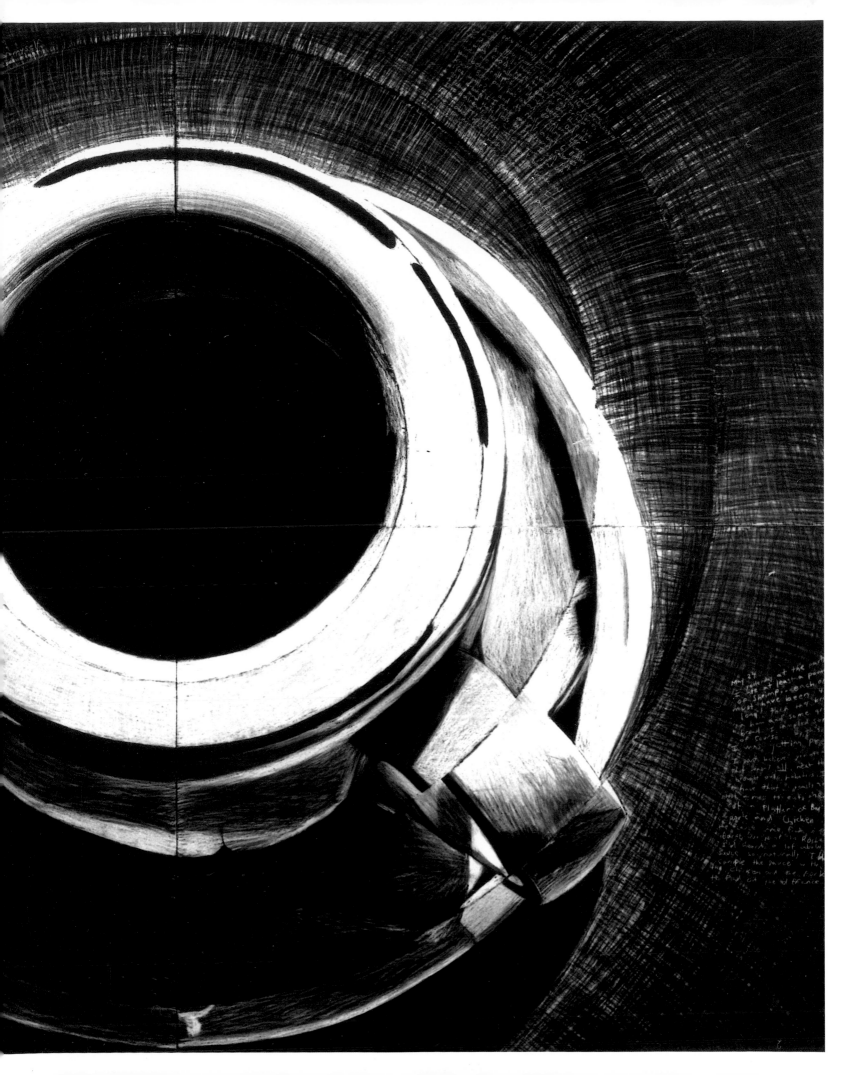

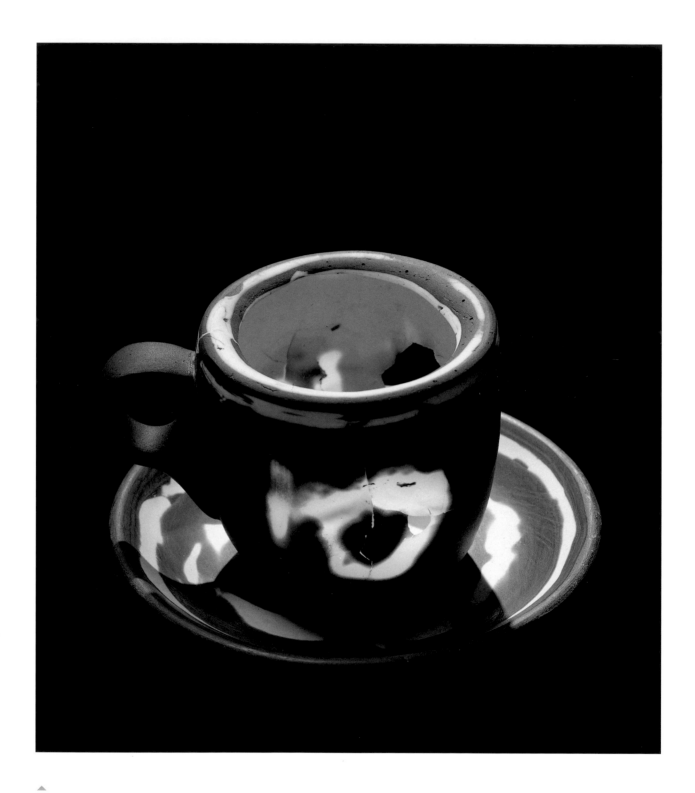

Betty's Cup, *1982*
Porcelain
3 1/2 x 5 x 5"
Collection Los Angeles County Museum of Art
Los Angeles, CA
Gift of the Estate of Betty M. Asher
AS1999.12 166

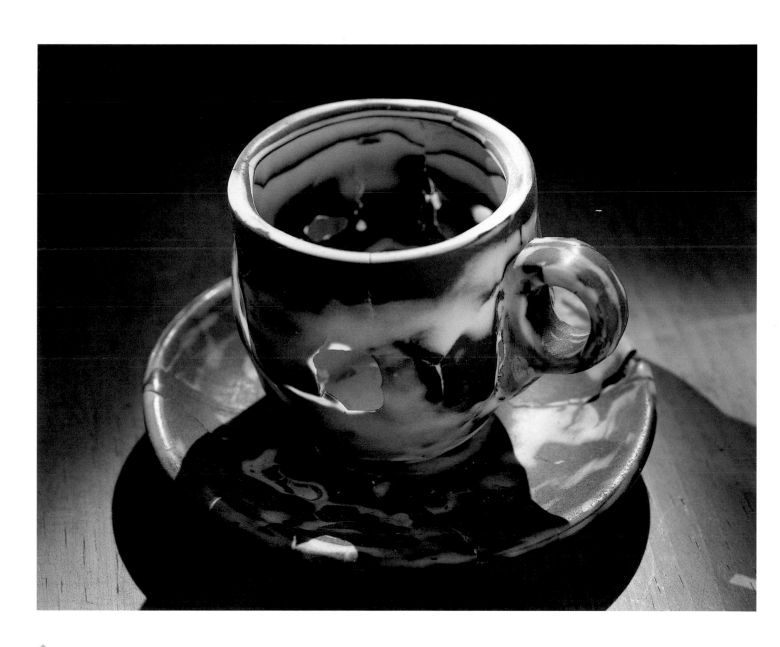

B-3, *1982*
Porcelain
3 3/4 x 5 x 5"
Collection Irene Bettinger
Kansas City, MO

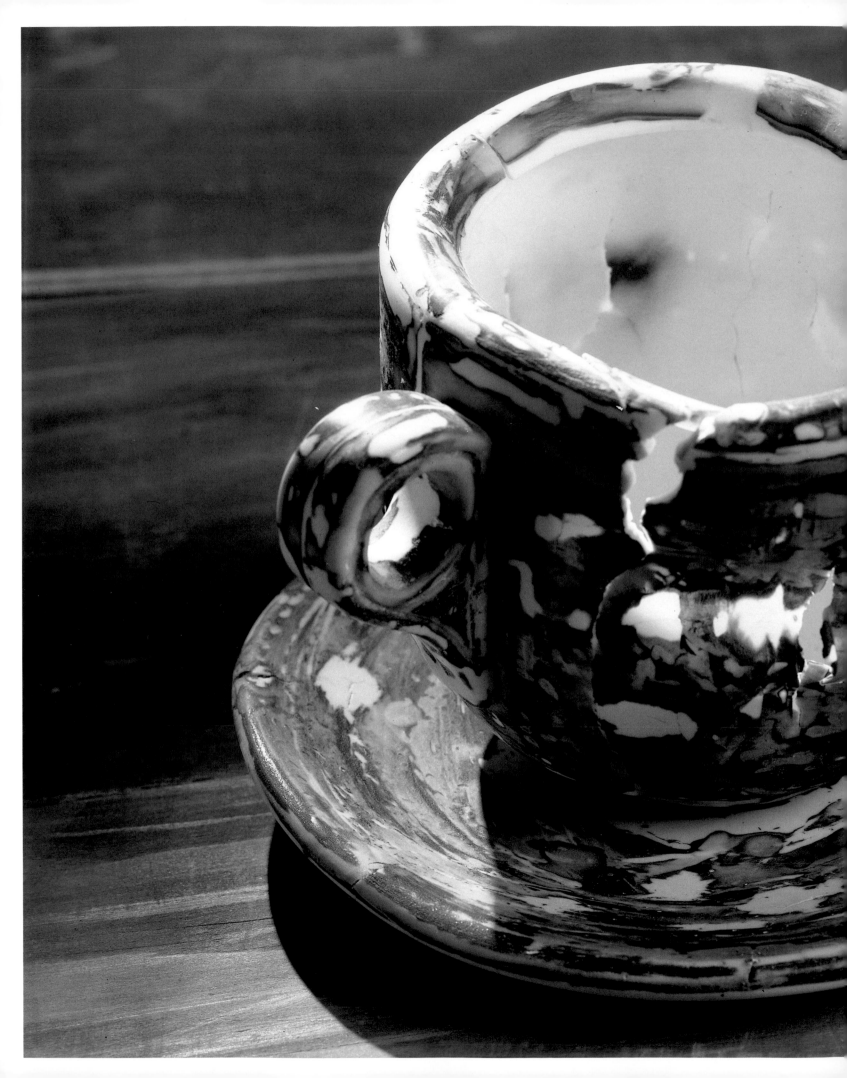

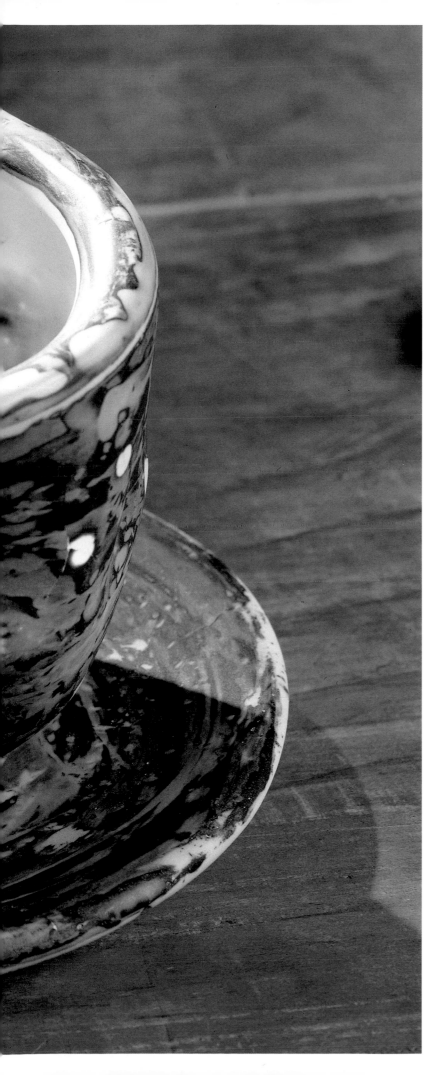

◄

A-14, 1982
Porcelain
5 1/2 x 8 5/8 x 8 5/8"

A-12, *1982*
Porcelain
5 1/2 x 8 x 8"
Collection Myra and Jim Morgan
Prairie Village, KS

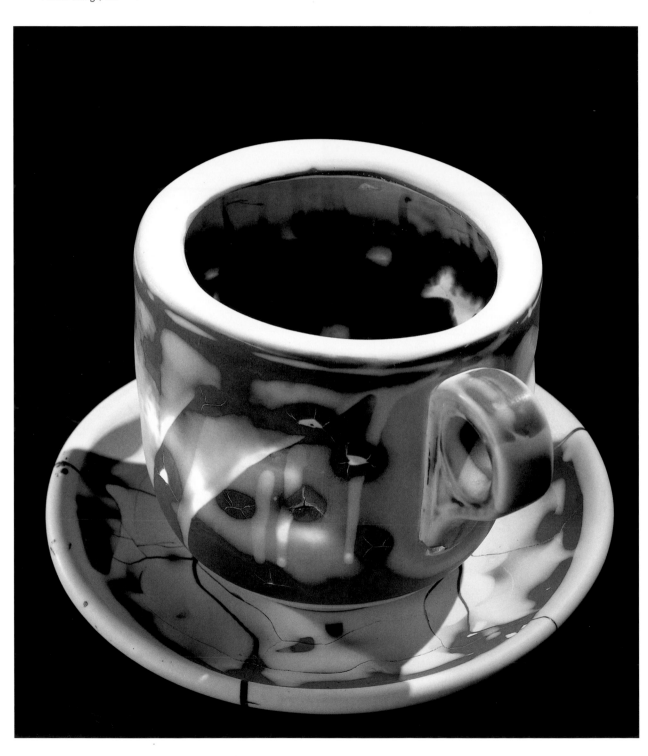

A-6, *1982*
Porcelain
5 5/8 x 8 5/8 x 8 5/8"
Collection Mint Museum of Craft + Design
Charlotte, NC
Allan Chasanoff Ceramic Collection

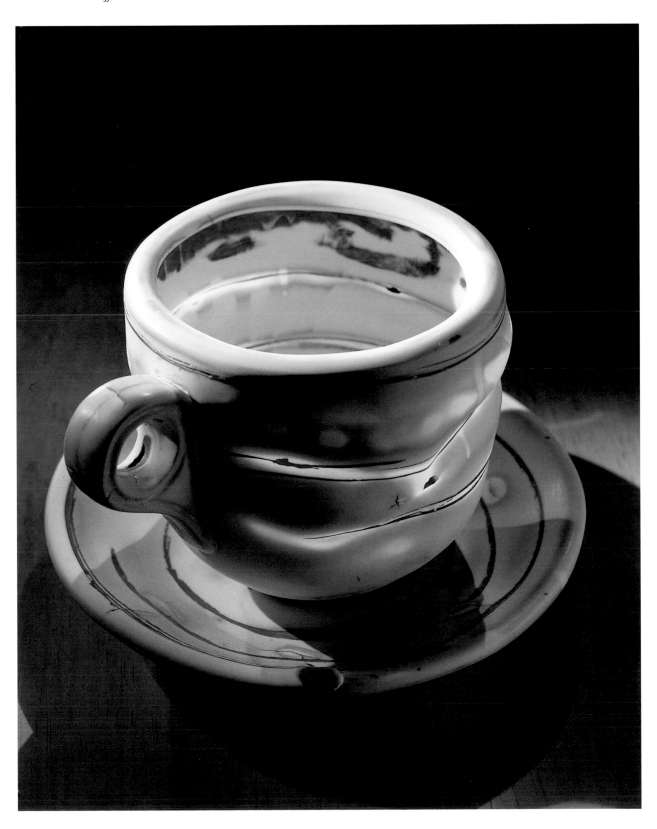

▶

Tex Talks Back, 1982
Porcelain
5 1/4 x 7 x 5 1/4"
Collection Estate of Howard Kottler
Seattle, WA

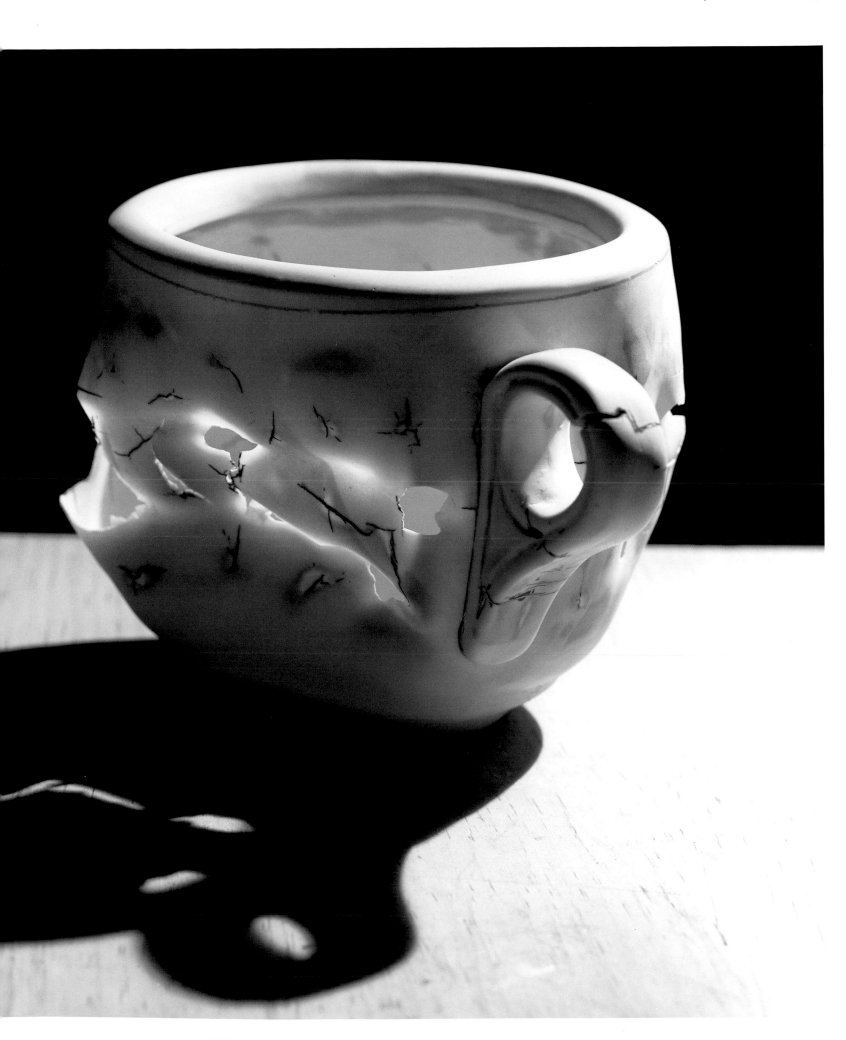

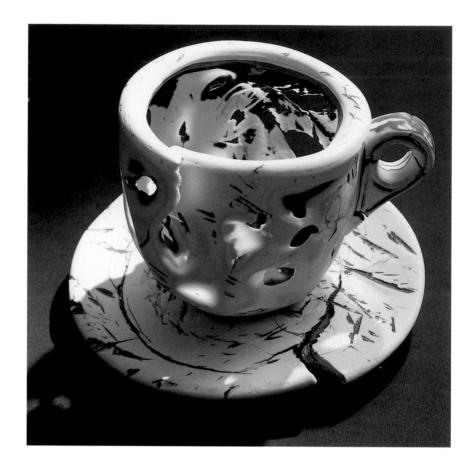

▶
Pink Cup, *1987*
Porcelain
5 1/2 x 8 x 8"

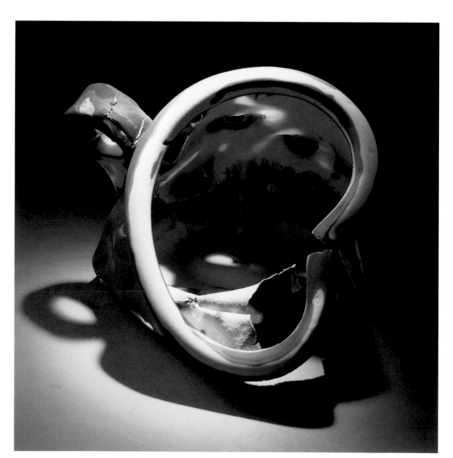

▶
Blue Cup #4, *1987*
Porcelain
5 1/2 x 7 1/2 x 4 1/2"
Collection Jim Friedman and Suzanne Stassevitch
San Francisco, CA

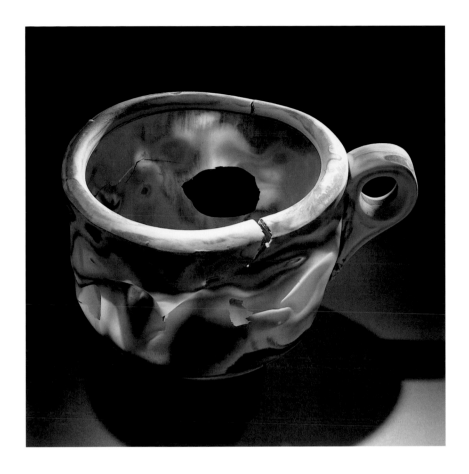

◀
Blue Cup #3, *1987*
Porcelain
4 1/2 x 6 1/4 x 4 1/2"
Collection Jim Friedman and Suzanne Stassovitch
San Francisco, CA

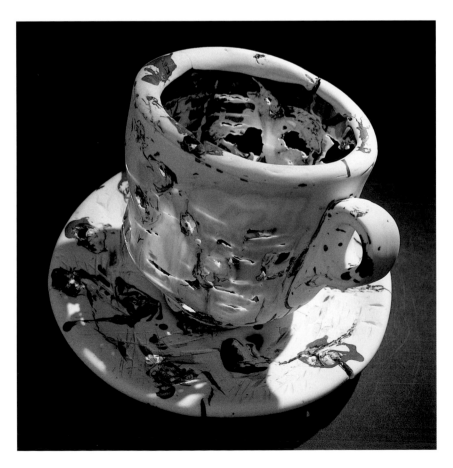

◀
Napa, *1987*
Porcelain
5 1/4 x 7 5/8 x 7 5/8"
Collection Carolyn Broadwell
Napa, CA

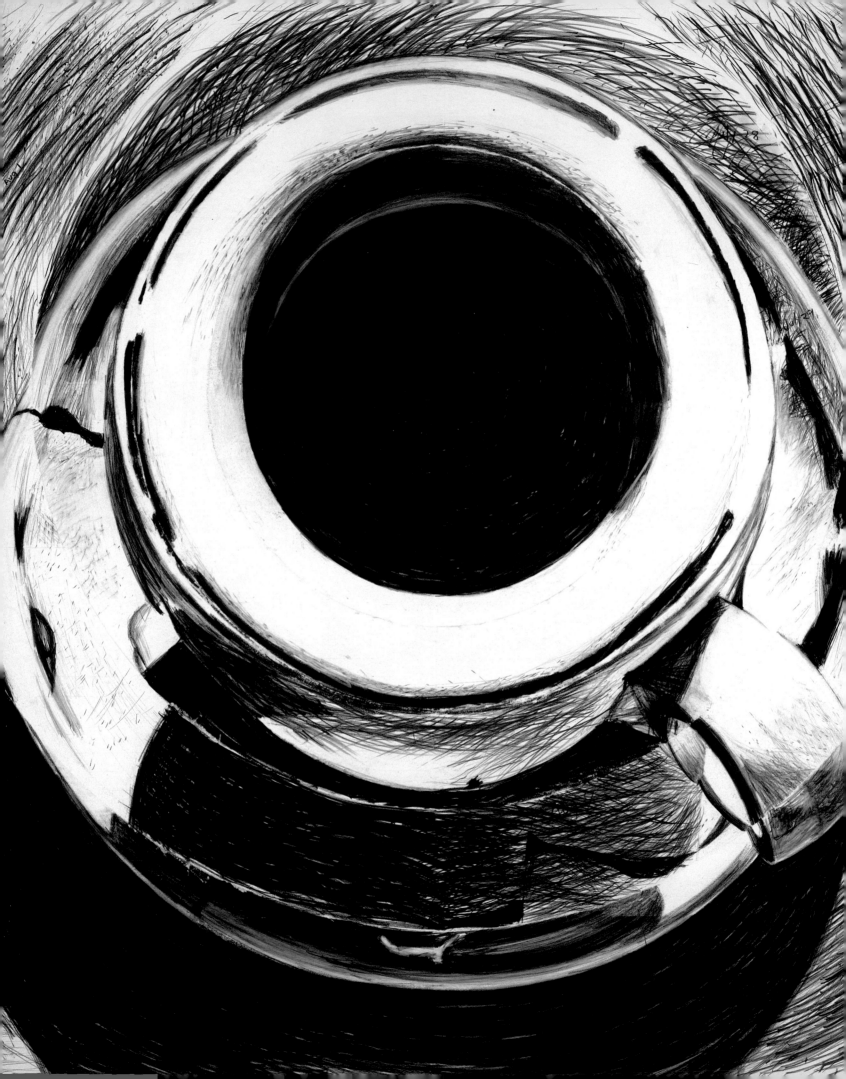

THIRD CUP OF COFFEE

Dr. Edmund Burke Feldman

Alumni Foundation Distinguished Professor of Art
School of Art
University of Georgia
Athens, GA

Cups and saucers continuously recur in Tepper's drawings and ceramics, which means that a single motif has given him sufficient occasion to say what he needs to say about art or life. This is not a case of an artist's fetish. Not exactly. Tepper likes china, to be sure, but he is also interested in making a statement to the effect that an ordinary cup and saucer, phenomenologically considered, constitute an arrangement of forms complex enough to support a generous array of meanings. As precedents we can consider Giorgio Morandi's bottles and jars, Jasper Johns' *Painted Bronze Beer Cans* (1960) or Meret Oppenheim's notorious *Object* (1936) – her scandalous fur-lined cup. There have been other humble objects raised by artistic ingenuity to noble (or shocking) aesthetic status. Stylistically speaking, Tepper employs a few Cubist fractures of plane and slices of shape, but style for him is no more than a device for calling attention to his beloved crockery. The function of his charcoal drawing or his "real" cups and saucers is to create images that will stimulate good talk, real conversation.

The viewer stares down into a black circle of java. The coffee in its cup, resting on its saucer, surrounded by a network of oval shapes and marks, creates a powerful arrangement of slightly eccentric circles punctuated by a thick round handle, a black crescent shadow, and some random nicks and cracks. The shapes produced by the curvilinear marks and hatchings are bold and insistent, which generates an almost mesmerizing effect. The curves form ever expanding circles and arcs not unlike sound waves. Where do they come from? What impels them outward into a progressively looser linear network? It is the black fluid: its heat and aroma have been translated into a web of reverberating sound. That coarse web is the visual equivalent of the guttural noises emitted from deep down in the throat when we're about to get a jolt of java. The "third cup" of the title may be the artist's way of saying he is almost awake: he hears the noises of morning, he blinks at the light of day, and he is ready to grasp the porcelain cup one more time.

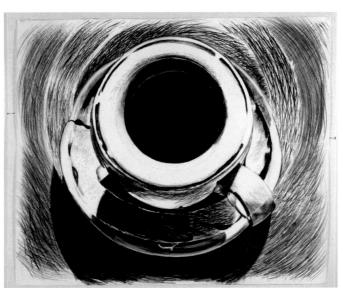

◀ ◀
Third Cup of Coffee, 1983
Charcoal, oil pastel on paper
43 3/4 x 51 1/2"
The Arkansas Art Center, Little Rock
Arkansas Arts Center Foundation Purchase, 1984 84.043

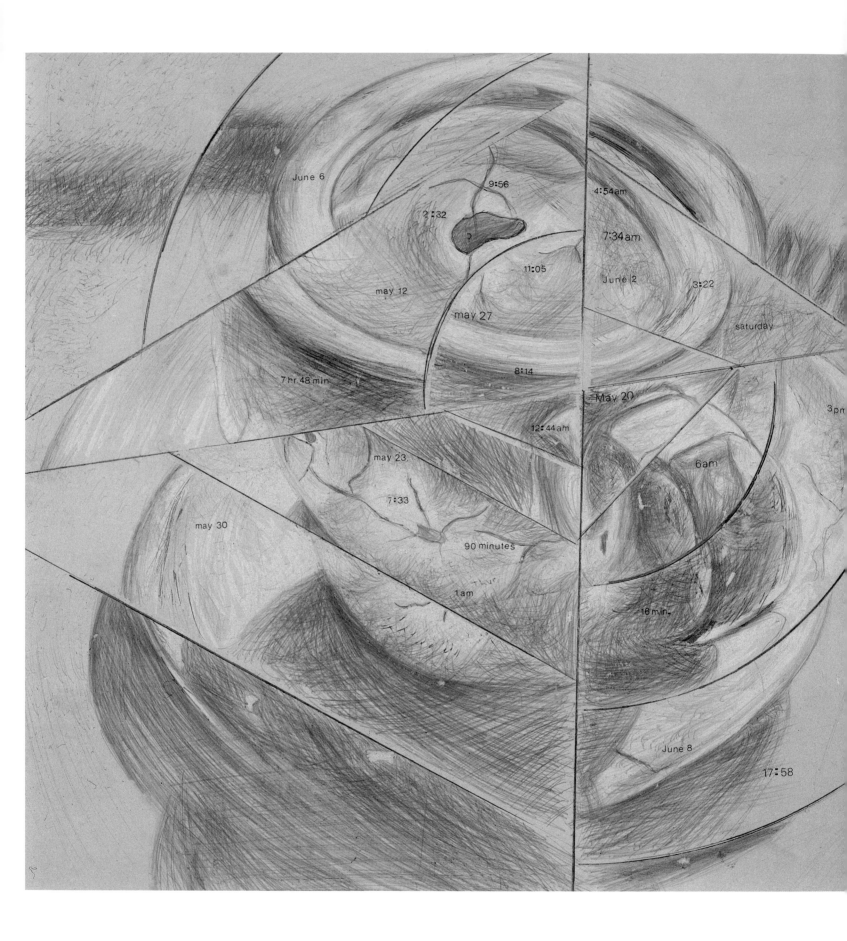

10:23 am

The central location of the cup and saucer, plus their heroic size (about fifteen times larger than normal) are declarations of focal and psychological importance. By their size they blast out the "news" like an overpowered radio: the nightlong fast is almost over, we are about to resume the daily grind. As for the repeated circles and arc, they say that the human spirit requires very little to revive it: we can be returned to life by a hot black fluid held inside a battered piece of crockery.

Notwithstanding the restorative power of black coffee, Tepper is mainly concerned with the coffee cup and saucer as an emblem, as the symbol of an idea or, in this case, a career. The utility of the crockery is incidental: it is the age, wear, and damage that counts. Which is why the saucer cracks (one in the light and one in the shadow) are so prominent. The artist is determined that we see these plain objects as worn-out heavyweights – low-priced performers, often injured and much exploited, never "contenders" in the fine arts league, yet deserving of respect because they are useful.

The aesthetic effect of Tepper's drawing depends, first of all, on the idea and reality of cheap restaurant ware – the sort one can see in the proverbial one-arm diner. It relies, secondly, on the values inherent in craft when it is dedicated to service and durability alone. It alludes, finally, to the dignity, that is, the worthiness, of objects (and by extension, persons) whose ambition is to be honest about who they are, and reliable in what they do. The prizefighter metaphor is obvious, but it is the club fighter, not the world champion, that Tepper has in mind. The story of this drawing can also be seen in a play: Rod Serling's *Requiem for a Heavyweight*. There, too, a third-rate pugilist earns our respect because he never "takes a dive." He goes down fighting.

This essay first appeared in the 1996 catalogue *Large Drawings and Objects*, and is reprinted here courtesy of The Arkansas Arts Center, Little Rock.

◀
Gold Point, *1987*
Gold Point and white gouache on prepared paper
14 x 17"

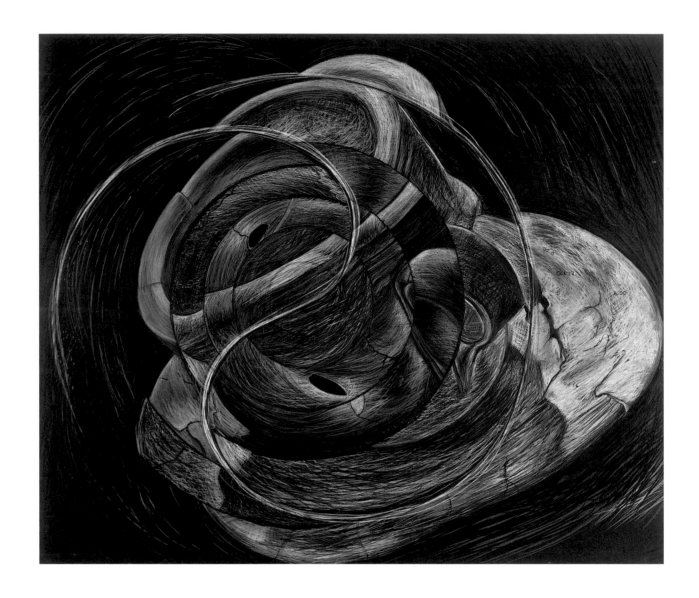

Ying Yang Morning, *1987*
Pastel on black museum board
40 x 60"
Collection Marc Freidus and Sandy Gilbert
New York, NY

April in Paris, *1989*
Pastel on black museum board
84 x 60"

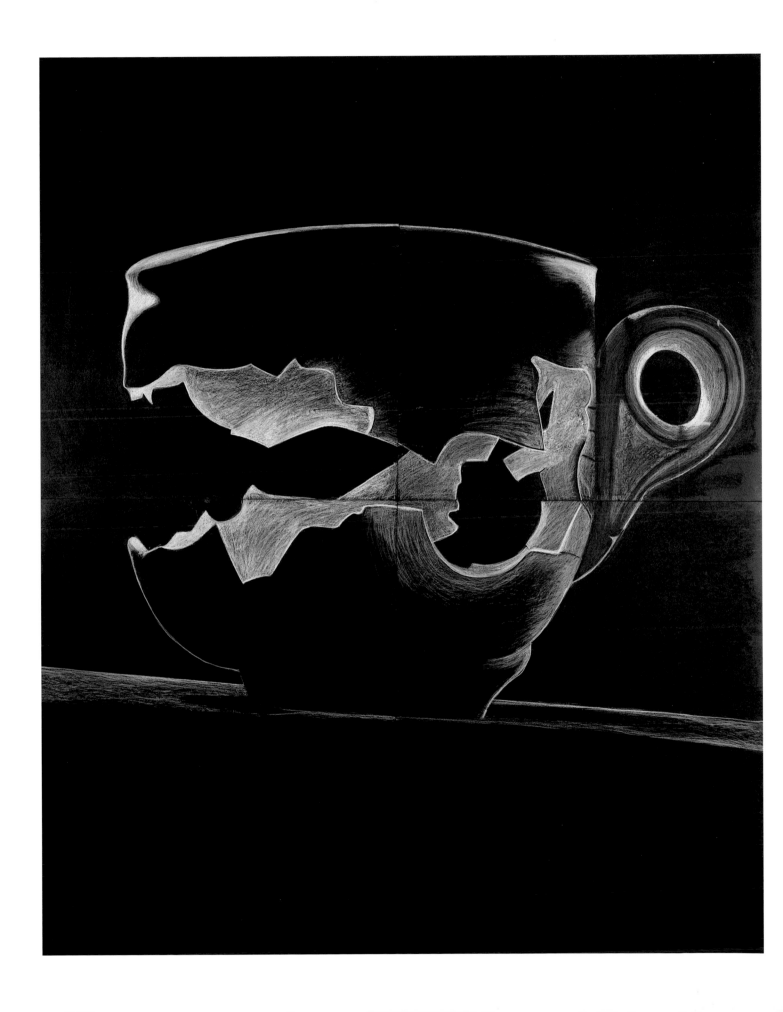

SACRED VESSELS

James Harithas

Director, Art Car and ACME Museums
Houston, TX

Irvin Tepper's best known contributions to contemporary art are the ceramics
and the bronzes, drawings, and photographs inspired by the common coffee cup.
Tepper's cups are transformed into sacred vessels because, although broken,
they are redeemed by the artist's aesthetic and by the rightness of their form, the
purity of their color, and the beauty of their porcelain surfaces.

To create his cups, Tepper relies on intuition, gesture, ritual, and his instinct for
the spiritual. His unique approach also derives from his mastery of ceramic tech-
nique, his free use of accident, his constant experimentation with a broad range
of media, and his striving to improve his inner life.

His dynamic, black and white cup photographs project an atmosphere of
mystery. The artist photographs the cups against an unusual background of burnt
and mutilated cardboard, so that there is a startling illusion of movement.

Tepper's masterful drawings are mandala-like evocations of the cup's place at
the center of his artistic universe. The cup represents the union of opposites;
that is, it structures emptiness and contains fullness. Tepper's cups are not
useful as containers of anything but his profound visual insights and spiritual
aspirations. The drawings are the artist's painstaking meditations on space and
linear structure. The portrait heads that he sometimes draws and his usual
subject, the cups, become transcendent through linear multi-faceted constructs
that relate Native American spirit lines to Cubist structure.

Besides being an expression of his spiritual self, the cups reflect Tepper's world-
view. They are metaphors for our bombed and broken world, a world that is
rejuvenated by the artist's skill and his abstract approach to form. The influence
of Peter Voulkos is evident in Tepper's art. Voulkos elevated punctured and
broken ceramic sculpture into urgent masterpieces of personal expression.
Tepper's vision is more intimate, his materials more fragile, and his sense of
form far less traditional.

◀ ◀

Native American Church (detail), *1992*
Gelatin silver print
8 x 10"

◀

Che Guevara's Tank, *1995*
Type C-print
20 x 30"

Like his cups, Tepper's cardboard sculptures are the result of his creative use of fire. The scarred, burnt surfaces and innovative shapes have the look and feel of sacrifice and resurrection.

His other photographic projects are of a different order altogether, revealing a social or political reference. His photographs of sleeping homeless men and women show them at their most vulnerable, making them less of a threat. His handsome photographs of hand-painted food signs reveal the American fixation on fast food; at the same time, they are a record of an authentic folk art tradition. Tepper has also documented the classic American car in Cuba and the destruction of the World Trade Center, in addition to many hundreds of works of art of professional interest to himself and for use as teaching aids.

9:24am, 2001
Digital print
8 x 10"

Unlike most artists who rarely stray far from the art world, Tepper is an inveterate traveler. He has crisscrossed the American continent, wandered the back-roads of the Far West, and explored the Third World. Out of a trip to Central America came a series of photographs that not only document the poverty of the indigenous people of the war-torn region but also reveal the horror of the military occupation of their villages. Once when surrounded by hostile soldiers with their weapons at the ready, Tepper continued taking their pictures. Even though his life was in danger, he would not be deterred from pursuing his art.

In or outside of his studio, Tepper works incessantly at making art. He excels in an impressive range of media: ceramics, video, painting, photography, sculpture, and drawing. He is also an innovative collector, connoisseur, writer, and art professor. His struggle for inner clarity is fundamental to his work as an artist, and to his vision as a teacher and as man of the world. His sacred vessels are an important contribution to the art of his time, precisely because of their beauty as works of art and their power as symbols of rejuvenation.

◀

Penitent, Guatemala *1990*
Dye transfer print
24 x 20"

▼

Sleeping Homeless, *2000*
Type C-print
24 x 24"

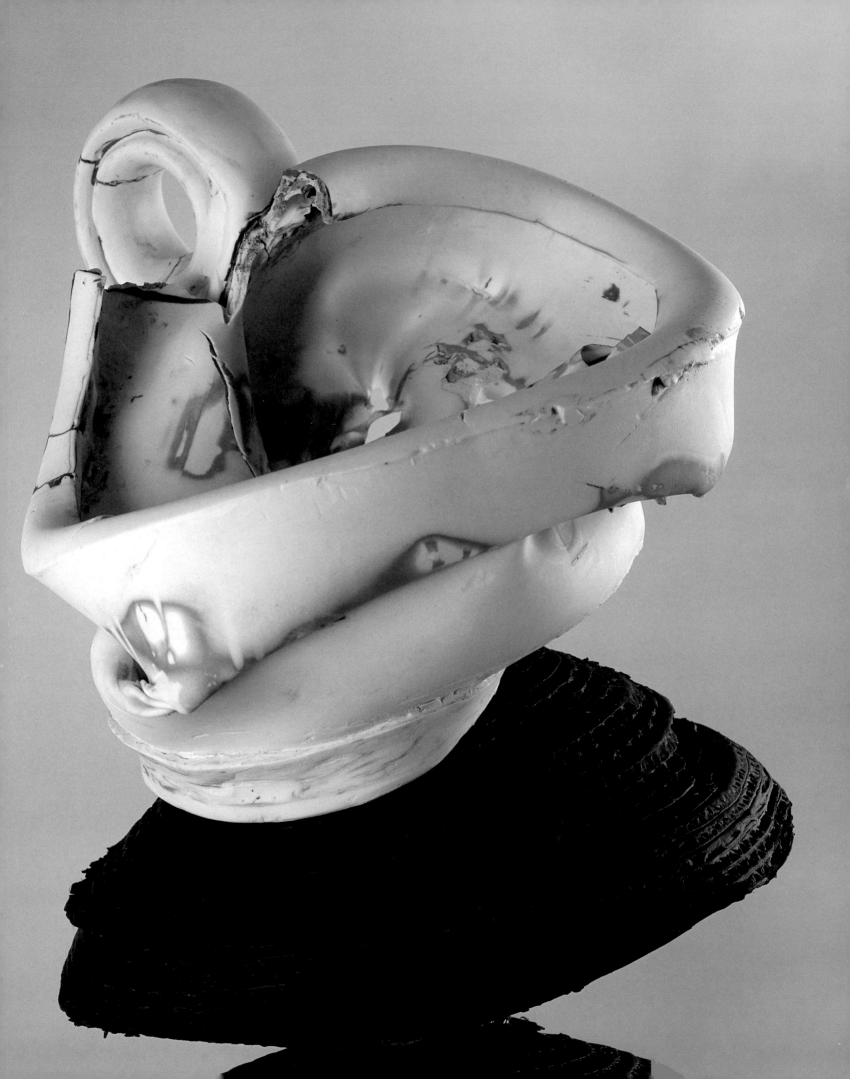

BURNT

David A. Ross

Brooklyn, NY

If this room could speak, imagine the tales it could tell. Stories about love and betrayal, kissing and killing, sadness and boredom, the endless seduction would replay as easily as a video. Sometimes, when I enter a strange room for the first time, I try to sense its stories. Often I find them etched in the pattern of wear on the floor, or in splattered forms staining the ceiling. Sometimes, the story emanates from one simple object abandoned on a shelf. If the feeling is particularly strong, that ghost of a story might hit me like a bad case of the chills. But what is this story? A long-faded fantasy or perhaps the shadows of some horrible truth, it's impossible to tell at first. But nevertheless, an undeniable sense of story permeates the space. It is available. Perhaps if I slept in this room, or even just day-dream long enough, I can enter into this story, take it apart, see how it works. Perseverance furthers.

Irv Tepper's ceramic work has often affected me this way, and I believe he has always intended his work to do so. In a Tepper cup one senses an object that has been around the block, so to speak. It has a story to tell. It is as if Tepper's tormented objects absorb and then reflect (or embody) the fierce energy and flailing desperation of failed idealism and faded dreams. It is as if Tepper consecrates the very notion of disillusion by offering us vessels which refute their function, while they insist upon radiating some completely alien message. Charity, faith, and courage. His works are neither simple symbolic objects, nor do they lamely mock religious narrative sculpture. They form an emotionally charged abstraction in which art's ability to transmute memory creates a novel ground for the language of dreaming. They tell lies that you want to hear. They sing in tongues.

Boston, August 1988

This essay first appeared in the 1988 announcement for Tepper's solo exhibition at the Gallery Paule Anglim, San Francisco.

◀

Faithful (detail), 1988
Cardboard, porcelain
59 1/2 x 20 x 20"
Collection Paul E. Hertz and James Rauchman
New York, NY

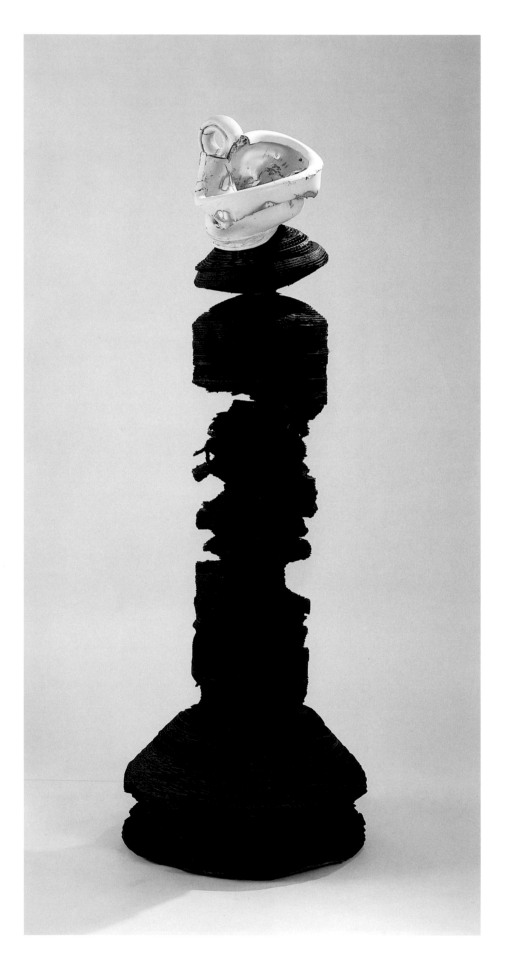

Faithful, 1988
Cardboard, porcelain
59 1/2 x 20 x 20"
Collection Paul E. Hertz and James Rauchman
New York, NY

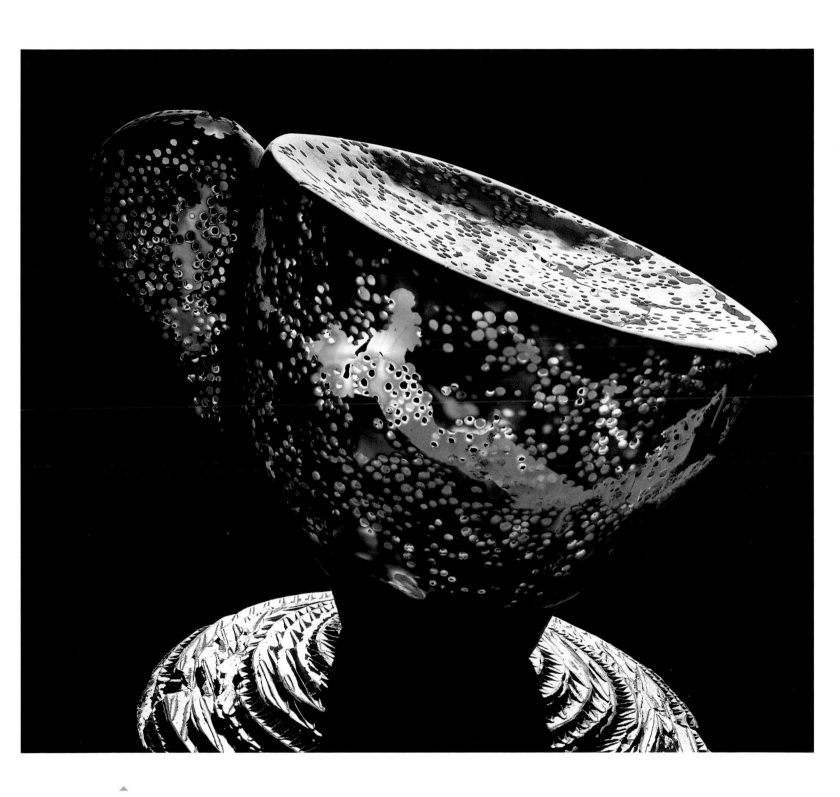

Tenacity (detail), 1988
Cardboard, porcelain
55 1/2 x 19 x 19"
Collection Dan and Jeanne Fauci
Los Angeles, CA

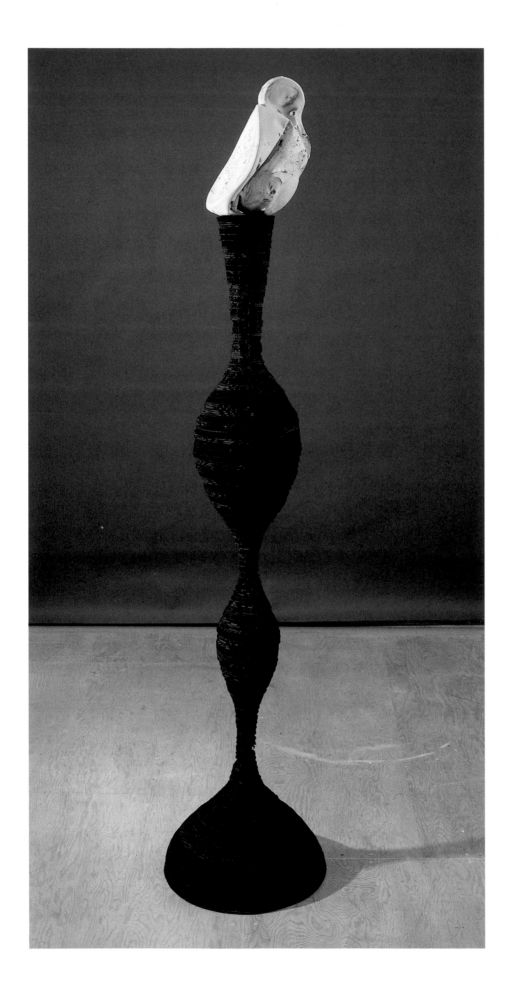

◄

Character, 1988
Cardboard, porcelain
79 x 20 x 20"
Collection Marcie McGahey Cecil
La Jolla, CA

▶

Character, 1992
Graphite on paper
64 x 66"

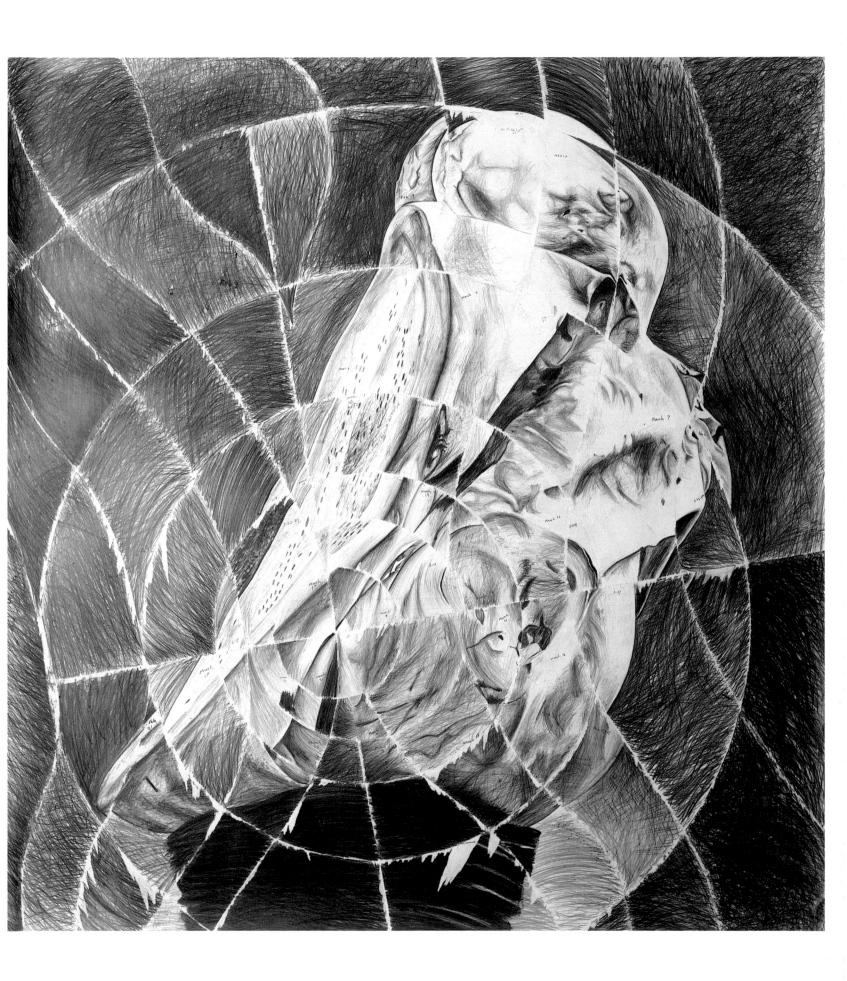

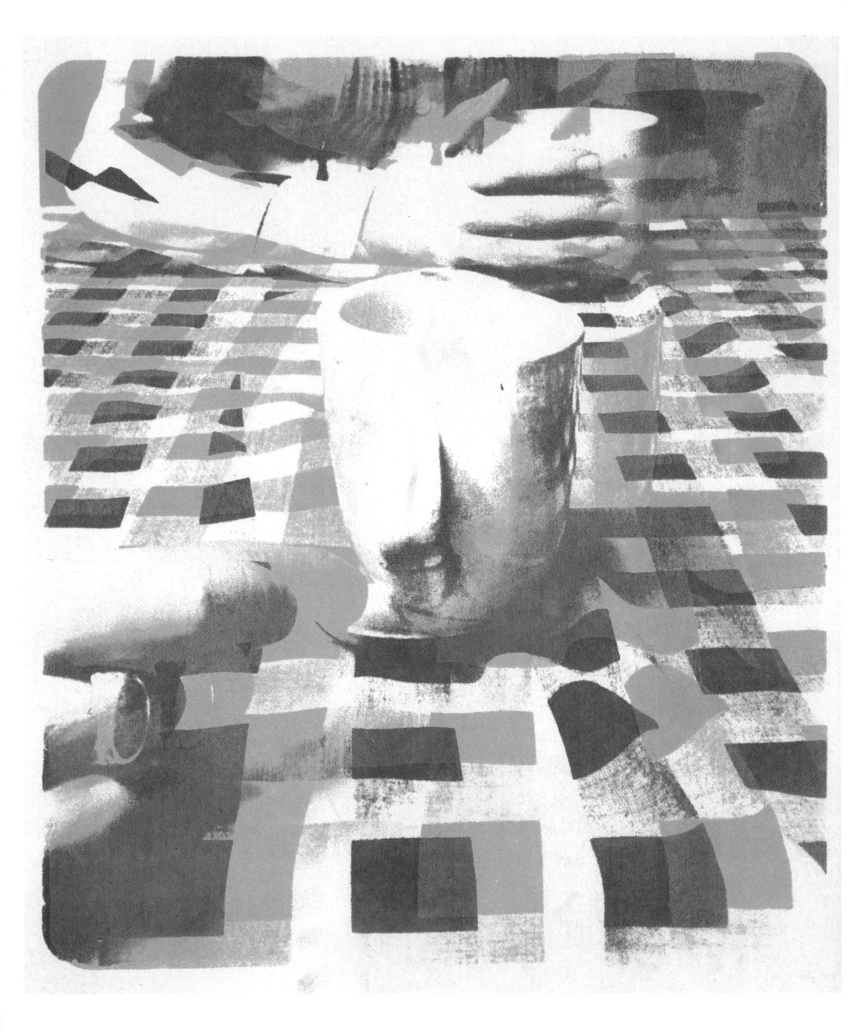

A Cup of a Photograph

Marc Freidus

Independent Curator
New York, NY

Photography has been a persistent component of Irv Tepper's dialogue with the cup for the past thirty years. At different times Tepper has turned to photography as a seemingly transparent medium for the production of conceptual artworks, as a compositional tool in his drawing process, and increasingly as a medium for the production of independent pictures. Photography, like the eavesdropping cup, can be a tool for extending the range of what we are normally capable of seeing or knowing, opening a portal into the unknown.

Tepper's first mature photographic works, made in Seattle and San Francisco between 1970 and 1972, came at a time when he was reacting against the focus on the ceramic vessel that he had been exposed to at the Kansas City Art Institute. Encouraged by Howard Kottler at the University of Washington, Tepper explored desire and his personal obsession with eating, creating miniature ceramic food tableaux. Ceramic works such as *Lemon Meringue Sea,* 1970, with its store-bought plastic people frolicking on a pie-wedge beach, humorously examined surreal shifts of scale as well as body consciousness.[1] On his own, Tepper photographed similar irreverent set-ups, such as a group of little plastic men scaling a mountain of prunes and apricots, or a group of miniature barnyard animals grazing in front of a naked female torso. At the color lab that processed his prints Tepper studied photographic technique, learning to light a still life with a single light, a technique he has used to photograph his cups to this day.

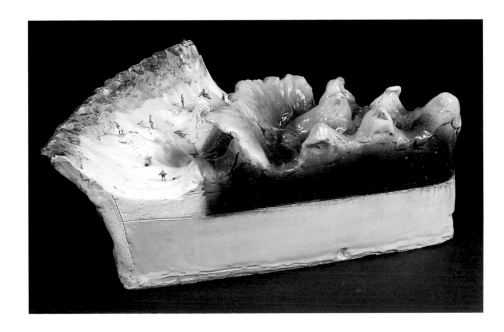

Lemon Meringue Sea, 1970
Earthenware, glaze, and plastic figures
9 x 24 x 12"

Stereo 3-D Silkscreen, 1976
Silkscreen
30 x 24"

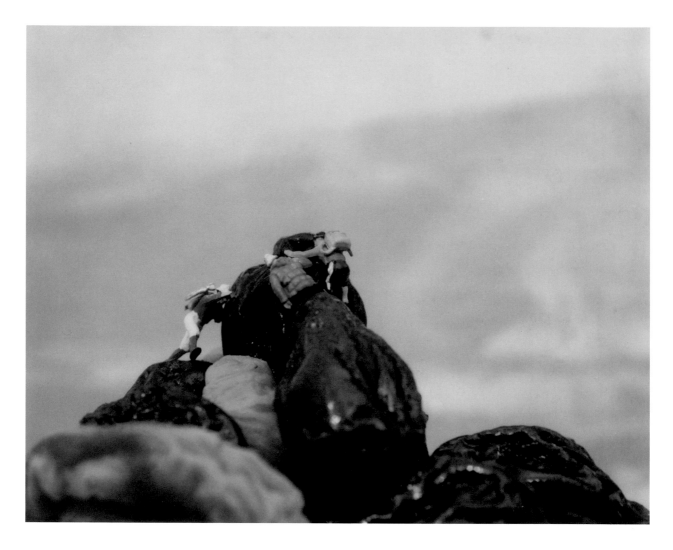

These set-ups played with the distortions of scale and context that photography is eminently capable of, deriving their effect by subverting the "common-sense" belief in the veracity of the medium. In their humorous, narrative exploration of perceptual issues, these works paralleled the groundbreaking photographic work being done simultaneously by William Wegman and Robert Cumming in southern California.[2] In a sense they show Tepper making a shift from the body-oriented work of a potter towards a conceptual or mind-oriented art. While the subject matter clearly derives from pop art and a sixties sense of anti-elitism, from today's perspective these works seem prescient and predictive of the post-modern staged and fabricated photography of a decade later. But Tepper's early photographic works were not widely seen, and to the degree they were post-modern, debunking notions of authenticity, they represented only one of many voices Tepper tried experimentally before his 1975 breakthrough work, *Idea Drawing for Flawed Cup*. Ultimately he would arrive at an edgier, less ironic voice than we usually associate with post-modernism.

Prune and Apricot Mountain, 1971
Laminated C-print
11 x 14"
Collection Aaron Freidus

Fake Vacations: At the Seashore, 1975
Type C-print
24 x 30"

Fake Vacations: In the Mountains, 1975
Type C-print
24 x 30"

Tepper's work between 1972 and 1976 involved a search for a medium that was personal, autobiographical, and able to invoke a heightened sense of space and body consciousness in the viewer. (Think of Vito Acconci for a parallel – pursuing similar concerns through different means). This included color photographs of "fake vacations;" a series of black and white photographic self-portraits depicting Tepper contorting and distorting his body while wearing a boldly striped shirt; videos – including one documenting Tepper's attempts to master his body by dieting; and a series of stereo photographs of coffee cups.

Tepper chose the stereo format in order to make an image that was unfinished until the three-dimensional illusion appeared in the viewer's mind. He experimented with several methods of creating this "direct brain stimulation," attempting to directly affect the viewer's consciousness. Tepper first tried a patently artificial technique where the image is printed by silkscreen in two overlapping colors (red and green) and is then viewed through a filtered viewer that converges the image. He also employed the traditional nineteenth-century method of pairing two adjacent black and white prints, shot off-axis, which converge when viewed through a stereo viewer.

Tepper made several stereo photographs of a possession that had long fascinated him:[3] a coffee cup with a crooked handle, stolen from the cafeteria in his first days at the University of Washington. Rather than photograph any of the other cups he had collected because he admired their form or decoration, Tepper focused on the cup with the flaw. The flaw gave the cup a life of its own, a force unintended by its maker, a quality that Tepper was determined to explore. It was also not lost on him that the cup's contents, coffee, also provided a form of direct brain stimulation. Tepper placed the cup on a checkerboard tablecloth to enhance the stereo illusion. He made several drawings from these stereo photographs, including *Idea Drawing for Flawed Cup* and *This Story Isn't Finished Yet.*

In these drawings Tepper developed his technique for fragmenting the image by drawing each gridded section separately. This extended in time both his experience of making the object and the viewer's experience viewing it. Unlike his videos in which the temporal dimension was fixed, by dividing the drawing into squares and placing multiple stories and diaristic notations around the image, Tepper finally had created an object which exhibited the experiential density and layered quality he had been seeking in his photographic and video work. He emphasized this slowed-down, intimate quality of the drawings in his 1979 SITE installation, placing a single, well-worn chair in front of each drawing and attaching a stereo viewer to each frame.

▲

Stripes, 1973
Gelatin silver print
Contact Sheet
16 x 20"

Throughout his career, Tepper has frequently used photography as a foil or counterpart for his expressions in other media. When he made studies for his early drawings and photographed his early cups, until around 1980 his photographs were straightforward and workmanlike. Although he carefully planned the tabletop composition, the backgrounds, and the lighting, as a rule the photographs seldom had the presence of independent art objects. By the early 1980s, however, Tepper began experimenting with different photographic techniques as a way of extending the experience of his cups.

Using tightly controlled studio lighting, Tepper was able to heighten the moods and personalities of his porcelain cups. He used a gentle, almost dissolving light in which to view *Daniel's Cup* (1983) or the cup in *He is Thinking . . . "I'll get even, just wait!"* (1982). On the other hand, in photographing *Tex Talks Back* (titled for the acerbic Howard Kottler), the inner glowing light of the cup is contrasted with its dark, ominous skull-like shadow. For Tepper, the fixed two-dimensional perspective of photography allowed him to heighten selective aspects of a cup. Often he showed the cup's ability to capture and transmit light; at other times he emphasized the abstract implications of a particular view that might be seen fleetingly, if at all, when viewing the cup itself. The overhead perspective in the photograph on which he based the drawing *Big Ear or Big Mouth* provides a particularly dramatic example.

Occasionally Tepper produced multiple views of a single cup, especially after he began to radically fracture the cups' forms in the late 1980s. The color photographs of *I'm Happy if You're Happy* (1987) show Tepper playing with the cup's fragmented form. The darker view shows a solid cup crashing in upon itself, in a demonstration of porcelain plate tectonics; the lighter photograph is more suggestive of a big grin or a profile view of Mickey Mouse. Neither is more than a fragmentary look at the possible forms the cup can take. Although the written stories disappeared as a component of Tepper's art, the cups are still complex characters, if no longer narrators.

In the 1990s much of Tepper's photographic work was devoted to subjects other than his cups. His color photographs documenting the slow growth of a rubber band ball combined the deliberate drawn-out process he used in creating his cups and drawings with his interest in the energy inherent in the discards and margins of society. Perhaps as a result of his trips through the New York streets collecting rubber bands from the sidewalk, Tepper began photographing the sleeping homeless. As in so many of his works, Tepper courted a deliberate clash of form and subject matter. These photographs emphasized the bold colors and baroque folds of the blankets and jackets the homeless draped themselves in. The pictures are visually seductive, but the subject is certainly not aestheticized.

▲

Idea photo for Ying Yang Morning, *1986*
Gelatin silver print
8 x 10"

Nice Quilt, 2000
Type C-print
30 x 20"

The most instructive photographic parallel to these pictures, I believe, are the works of Aaron Siskind. Siskind's works seek to create a new photographic world, alive and populated, by abstracting signs from the urban scene. They generate enormous tension in their simultaneous presentation of marks on a picture plane and the suggestion that the lively forms they show are "out there" in the "real world," if only we are attentive enough to see. Speaking of his own work in 1945, Siskind could have been commenting on Tepper's photographs when he noted, "they are informed with animism – not so much that these inanimate objects resemble the creatures of the animal world (as indeed they often do), but rather that they suggest the energy we usually associate with them. Aesthetically, they pretend to the resolution of these sometimes fierce, sometimes gentle, but always conflicting faces."[4]

Of course, Tepper's colorful street photographs do not look anything like Siskind's monochrome abstractions. But Siskind's darker works do have a visual analog in Tepper's elegant, sensual, black and white images of the bronze cups of the 1990s. Here, Tepper has blown the cup's form apart and photographed it enveloped in darkness, occasionally resting on a spiderweb-like base of corrugated cardboard. The cups are lit using the technique that Tepper learned in Seattle thirty years ago, a single bulb carefully directed and, where appropriate, reflected. The bronze cups have shimmering highlights, but their contorted forms recall nothing so much as cooled volcanic lava or the melted shards of glass bottles distorted by the nuclear explosion at Hiroshima.

In his ceramics, drawings, and photographs Tepper has taken the idea of the cup and used it as a cloak, a disguise for a multifaceted examination of the self and the self's place in society. In the bronzes and modernist photographs of the 1990s Tepper operated in a baroque operatic mode, aware of the approaching millennium. The distance from the *Complaining Cup* or the humorous food photographs of the 1970s is stark. Tepper's works have moved from the personal to the universal, from the comic to the tragic. The brash casual attitude of youth has left Tepper's works, but in their freshness, their response to the changes that life throws out, Tepper's photographs and cups step confidently up to the plate, ready to swing.

Notes:

1. *Lemon Meringue Sea*, as well as some of Tepper's early photographs, entered the collection of Dr. Joseph Monsen around this time, Tepper remembers Monsen introducing him to the work of Diane Arbus shortly before her suicide in 1971. This fact and other background information is drawn from my conversations with Irv Tepper in January 2002 as well as a transcript of his unpublished 1983 interview with Paul Schimmel.

2. Some time after the first of these photographic tableaux, Tepper learned of Cumming's work from ceramic artist Clayton Bailey, including Cumming's 1971 self-published book *The Weight of Franchise Meat*.

3. In 1983 Tepper called it "the greatest thing I'd ever seen in my whole life."

4. Aaron Siskind, "The Drama of Objects," *Minicam Photography*. Vol. 8, No. 9 (June 1945), pp. 20 23.

Tex Talks Back, 1983
Gelatin silver print
8 x 10"

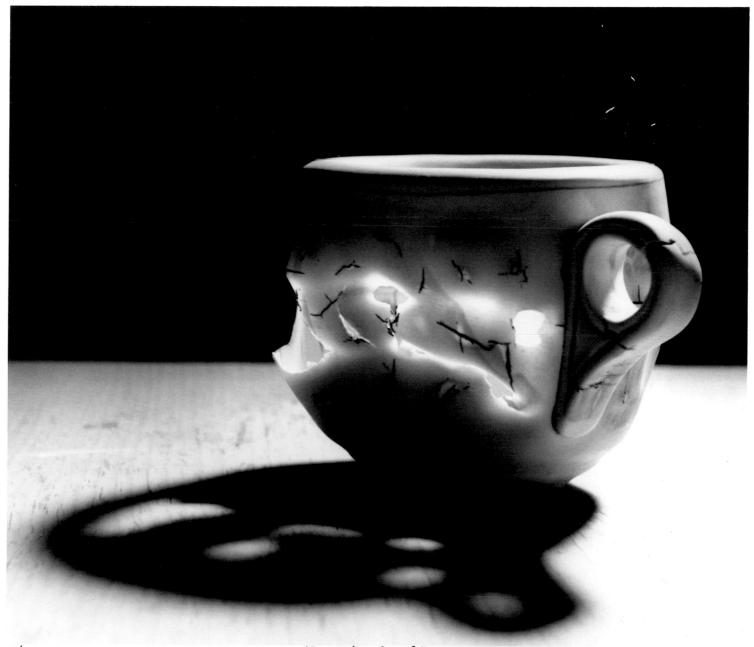

2/10 "Tex Talks Back" Arvin Frapis 1983

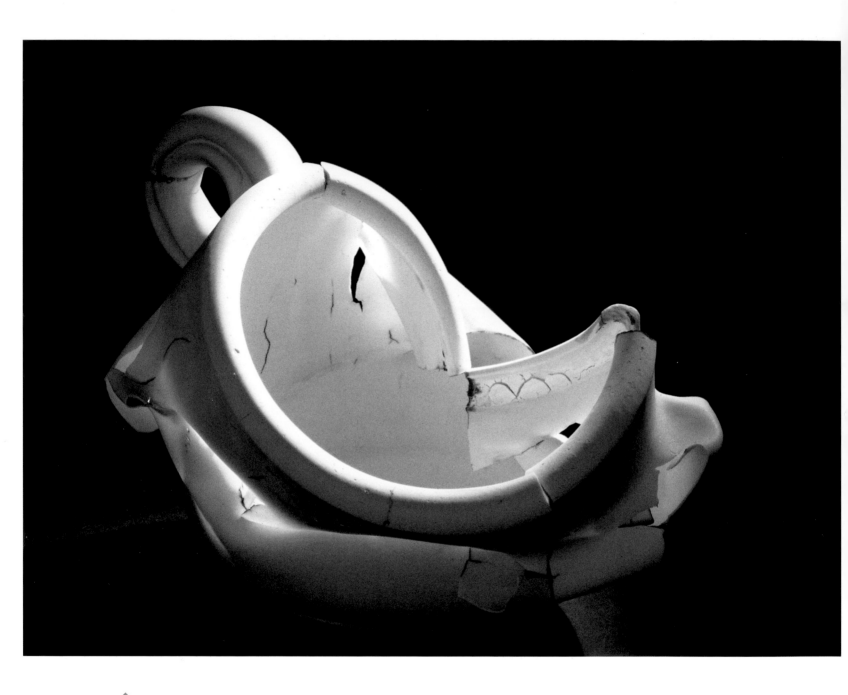

I'm Happy if You're Happy (view 2), 1986
Type C-print
16 x 20"

I'm Happy if You're Happy, 1986
Porcelain
9 1/2 x 14 x 10 1/2"
The Arkansas Art Center
Little Rock, AR
Foundation Collection
Purchased with a gift from Vineyard in The Park 1987. 87.019

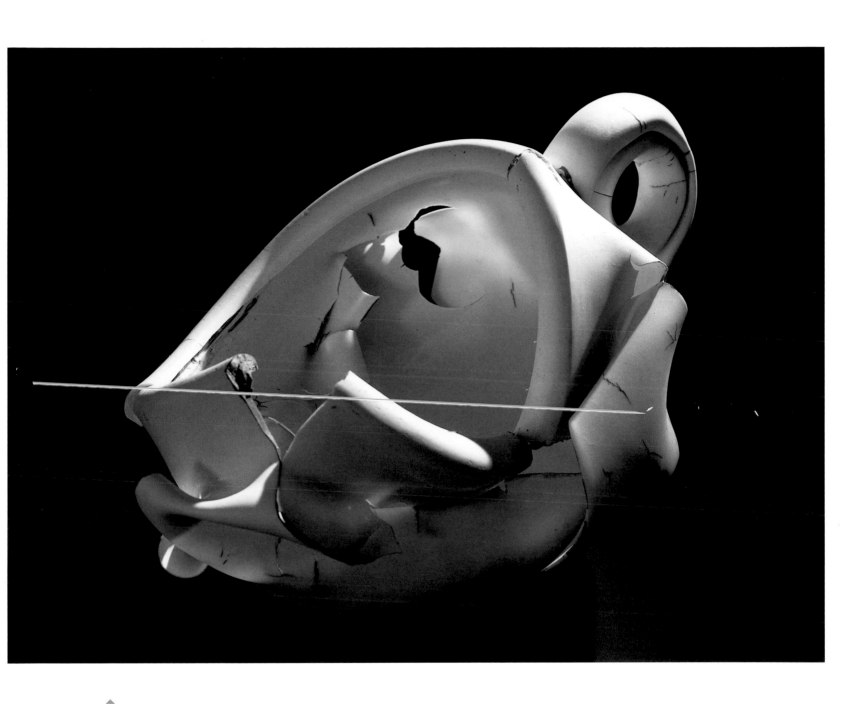

I'm Happy if You're Happy (view 1), 1986
Type C-print
16 x 20"

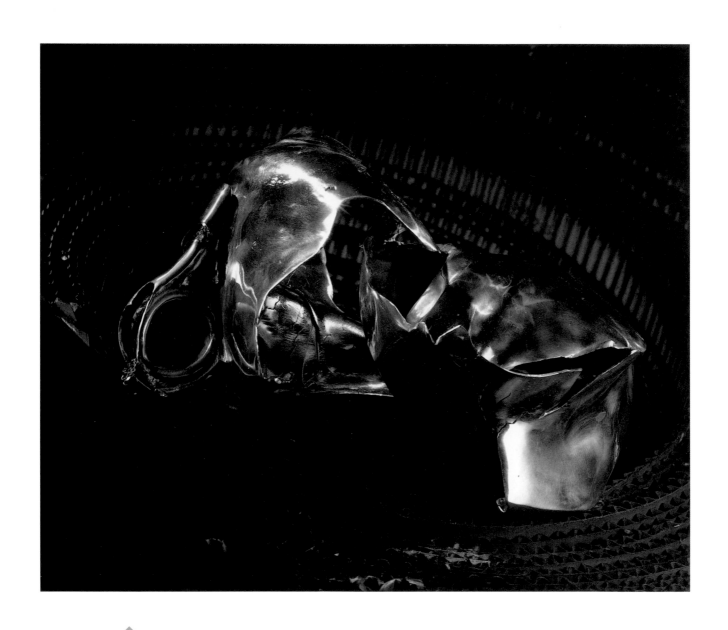

Nightride, 1994
Selenium tone silver print
20 x 24"

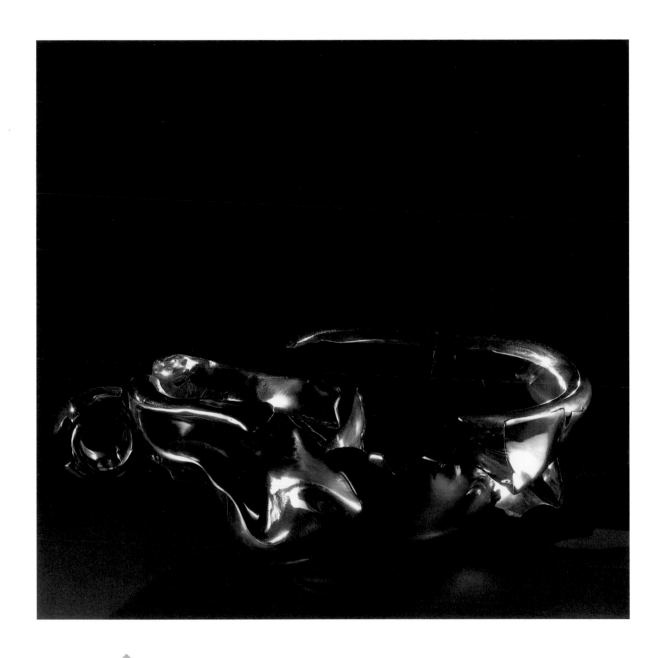

Dragon, 1994
Selenium tone silver print
24 x 20"

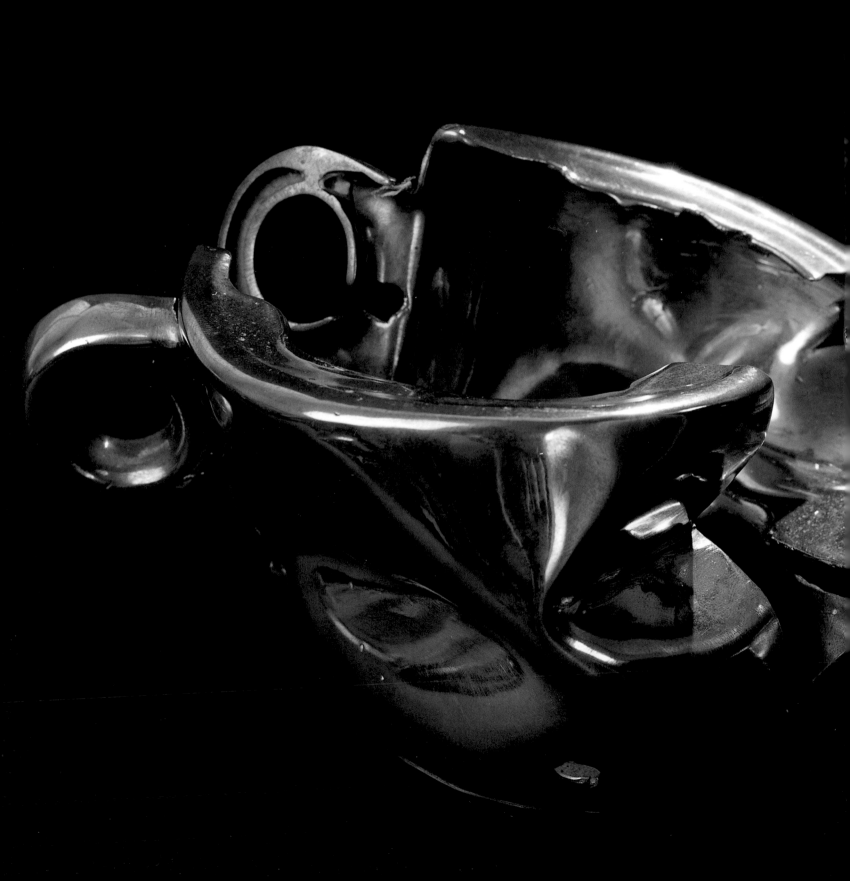

FORMA, LUZ Y POSIBILIDAD

Armando Suárez-Cobián
Writer and Poet
New York, NY

Me he acercado a ver las piezas de Tepper con la curiosidad de un arqueólogo. Las piezas en sí se parecen más de lo que yo creía pero se diferencian en lo que más se parecen. Y no me refiero ni al material ni a las formas y su belleza implícita, eso es demasiado obvio, me refiero a su interacción con la luz. Tepper es un escultor de la luz, esculpe con la luz, con las manos del fotógrafo y con la pasión del alquimista.

En las piezas de bronce como en algunos aspectos de la vida misma, no sólo tiene dominio de las formas sino de la luz. Tepper primero moldea las piezas en cera con la precisión y la delicadeza con las que se construye un espejo. Al final, estas piezas que terminan en bronce parecen haber sido descubiertas en un sitio lejano, y no sabemos muy bien si pertenecen al pasado o a una civilización del futuro pero sí que reflejan la luz, y en esta refracción de la luz se visualizan algunas de las intenciones del artista.

En las piezas de cerámica Tepper trabaja con la misma pasión pero no tiene el mismo dominio sobre el resultado final. Imagen y posibilidad en algún momento se separan y terminan siendo lo que el fuego ha de decidir, como en la antiguedad. En estás piezas en las que el azar hace su parte, la luz no se refleja sino se transparenta, la luz atraviesa la forma, enriquece la imagen, sugiere nuevas formas, crea otra posibilidad, otros caminos, que van redefiniendo su obra y su destino.

FORM, LIGHT AND POSSIBILITY

I approach Tepper's pieces with the curiosity of an archaeologist. They are more similar to each other than I would have expected, but they differ most in their similarities. I am not referring to the material, nor to the forms and their implicit beauty; that is too obvious. I am referring to their interaction with the light. Tepper is a sculptor of light – he sculpts with the light with the hands of a photographer and with the passion of an alchemist.

In his bronze cups – almost as a reflection of life itself – he not only has dominion of the forms but of the light. Tepper first molds his pieces in wax with the precision and delicacy with which one constructs a mirror. After the casting, their mystery is such that the bronzes appear as if they were discovered in a far away place; we don't know whether they pertain to the past or to a civilization yet to come. But we do know they reflect light and in this refraction of light we can visualize some of the artist's intentions.

In his ceramic cups, Tepper works with the same passion but does not have the same control over the final result. Image and possibility separate at some point and end up being what the fire decides – like in ancient times. In these pieces in which chance plays its part, the light does not reflect but is transparent. By passing through the form, the light enriches the image, suggests new forms and creates other possibilities, other paths, which will redefine both Tepper's work and his destiny.

◀

Gemini (detail), 1990
Bronze
3 1/4 x 7 1/2 x 4 1/4"
Collection Geanne Finney
New York, NY

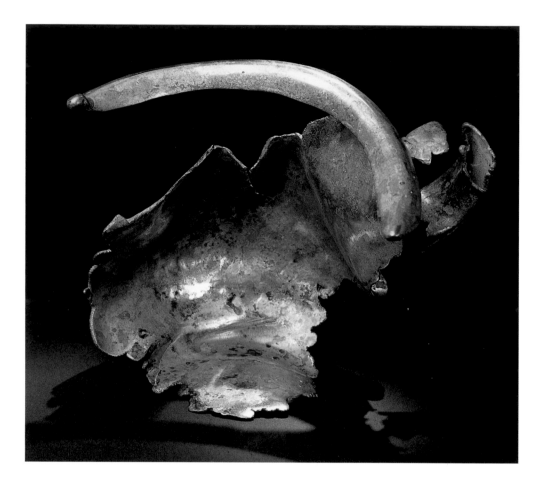

▸

...But Not Out, *1991*
Bronze
5 1/2 x 6 1/2 x 5 1/2"

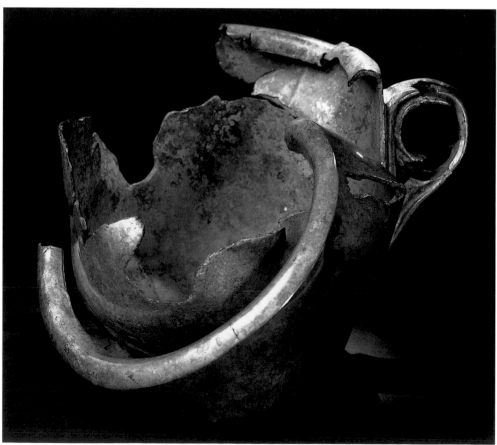

▸

Surrounded, *1990*
Bronze
5 1/2 x 8 1/2 x 6 3/4"

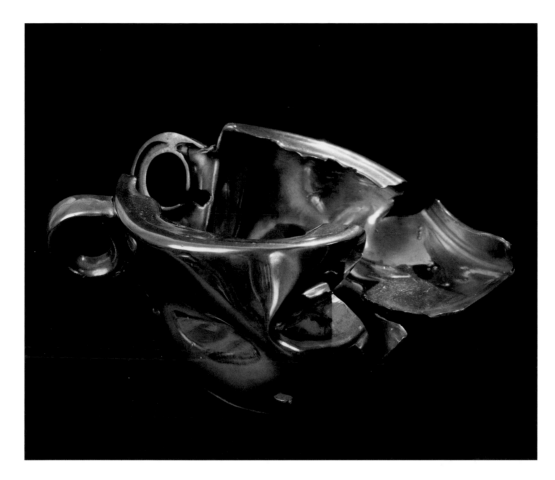

◄

Gemini, *1990*
Bronze
3 1/4 x 7 1/2 x 4 1/4"
Collection Geanne Finney
New York, NY

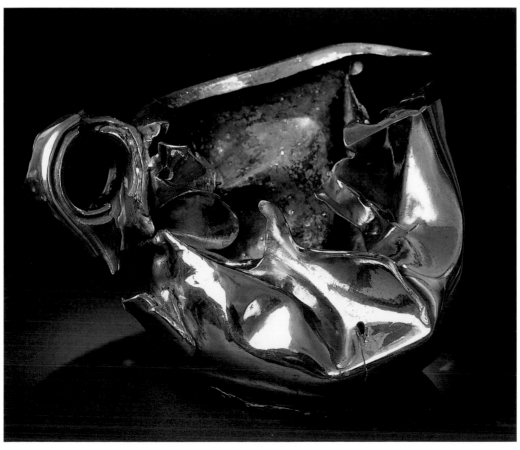

◄

Sterling, *1992*
Bronze
5 1/2 x 9 3/4 x 5 1/2"

Dragon, 1992
Bronze
5 1/4 x 12 x 6 1/2"

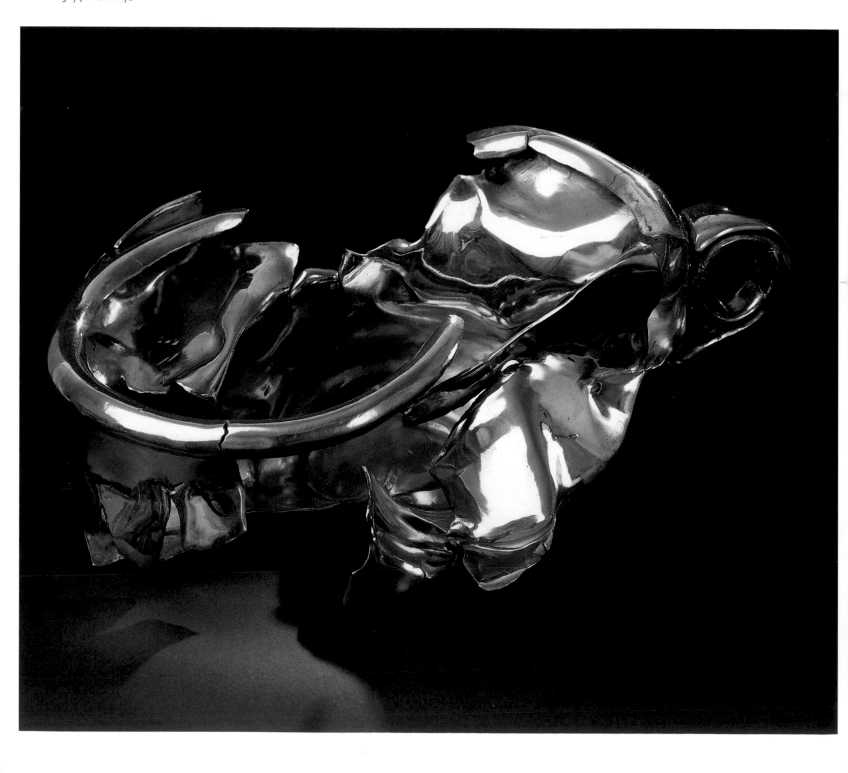

Nightride, *1992*
Bronze
5 x 9 x 8 1/4"

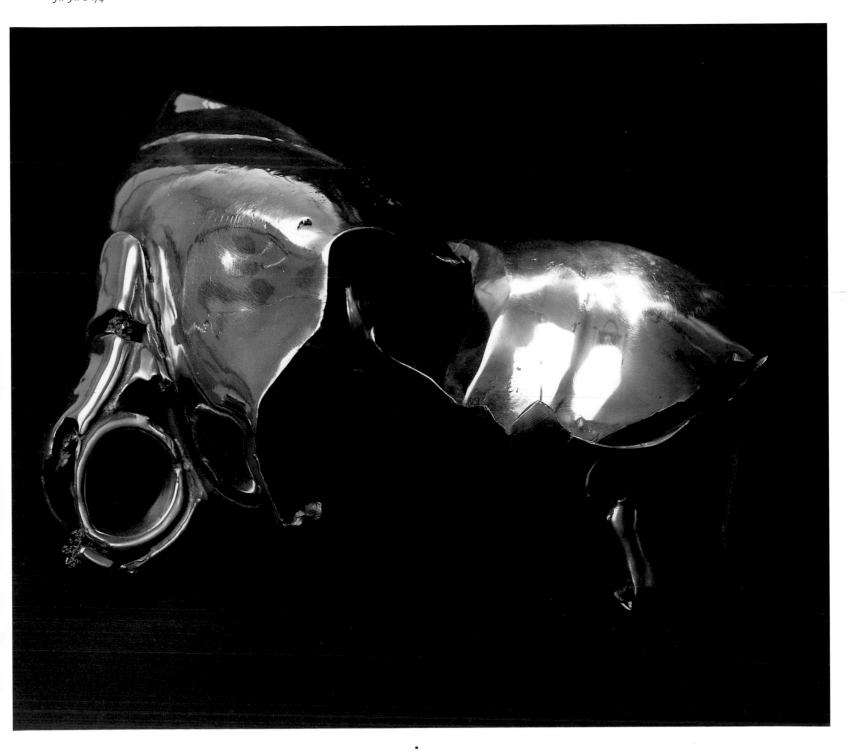

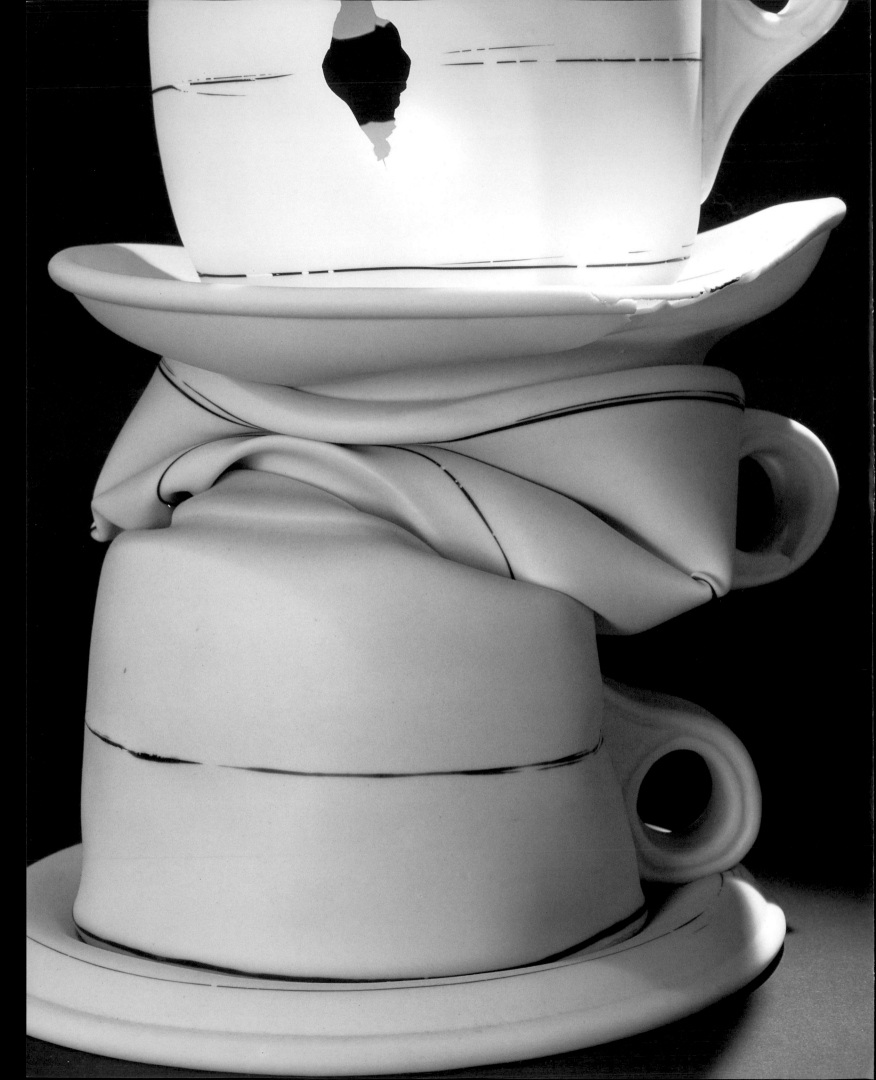

NON-STANDARD: IRV TEPPER'S OPPOSITIONAL CUPS

Janet Koplos

Senior Editor
Art in America
New York, NY

Irv Tepper has a collection of restaurant china cups. They line the kitchen wall of his SoHo studio in an abstract arrangement of sets and families and unique examples, while more pile up on shelves. Looking at his art works, it seems obvious that these thick, sturdy collected cups have not just influenced but totally determined the cups that have long been his ceramic subject matter. He's gone elsewhere in other artistic materials, but in clay, for Tepper, restaurant-china cups rule.

More or less.

While the cups he makes have a general shape that's easy to recognize, in fact Tepper contradicts nearly every characteristic of restaurant china. What is the utilitarian stock of diners if not chip- and breakage-resistant, neutral in color, balanced and comfortable in contour? Tepper's cups are none of those. His story — and Tepper is very fond of stories — is that he was initially fascinated by a mass-produced cup that had a crooked handle: somehow, this standardized form was not standard. It had been made imperfectly. Imperfection is a surprise, a divergence — and therefore more visually intriguing than perfection, which matches a given expectation. Tepper chooses imperfection for its formal interest and for its implications.

His persistent theme has been the broken cup — but not broken as a restaurant china cup would be, in shards. Tepper's cups are perforated, gashed, sliced, squashed. Damage and distortion contradict the notion of sturdiness and suggest that the ceramic wall is simply a membrane, as thin and vulnerable as skin. Light cast upon Tepper's cups endorses this impression, for the cup walls are largely translucent, not bluntly opaque like diner cups.

Besides that, the details of form are not as much like restaurant china as they first seem. Tepper's rim is a sharp-edged shelf, not rounded and continuous so as to be comfortable for the mouth. The handle's circular center is equally sharp-edged, which would not be comfortable for the finger. What these shapes do, instead of yielding to user convenience, is aspire to abstract or ideal form. Tepper's cups are not service pieces but pure shapes that detach themselves from everyday reality. They encourage viewers to see them as passages to a contemplative reality, as rings floating in space, usually at a steady perpendicular relationship to each other but most often not steady in relation to tabletop or onlooker. Instability is another typical feature of Tepper's cups.

The works violate restaurant china conventions in still another way: color. Where the china is usually a bland off-white or a robust, healthy solid hue, perhaps embellished with a logo or souvenir scene, Tepper's cups are foggy white or a mottled black and white reminiscent of dyed patterned fabric or abraded paint. His combination of opposites — the all-color of black and the no-color of white — could seem dispassionate and noncommittal, but that would be out of character for Tepper. Opposites of course, are also metaphoric.

Defeat is Nothing More Than a Signpost on the Road to Victory, 1999
Porcelain
10 1/2 x 9 1/2 x 9 1/2"

The nine porcelain cup works of *The Happy Rooms of Mystery* series, dated 1991 to 2001, are given titles that imply states, relationships, or events. Tepper's literary inclinations, primarily expressed in his drawings with texts, are also given vent in these titles. There is seldom a direct correspondence between words and form, or any sense of illustration. The words are simply provocative fragments that encourage viewers' imaginative openness to the work. These works include one, two or three cups, and sometimes saucers.

Eva's Enigma, with its single bashed cup resting on part of a lurching rim and broken handle, encourages a view deep within the pale, soft, translucent clay, as if into a personal space. *They Don't Know Why They Like Each Other*, on the other hand, consists of three cups and one saucer, stacked totem-pole fashion. The base cup is rim down, the middle one is smashed over it, the saucer flares out like an Elizabethan ruff, and the top cup is relatively intact. The whole violent, drunken assembly is white with just a few fine black lines that remind the viewer of Tepper's consistent interest in drawing. *Cups in Trouble . . . Perfectly* pushes the notion of violence even further with two cups and saucers forced together. One cup is rim down and the other more or less on its side; the saucers seem to flop against each other as softly as elephant ears. In this work, the black and white opposites are mediated by gray streaks and waves in effects somewhat more open and languorous than marbling. The result is both elegant and sensuous, particularly if one closely studies the folds and bends that recall the clay's previous softness, and notes how the gray trails off like a wisp of smoke.

In these three examples, one sees a spectrum of implications, from brutality to eroticism, from unity to destruction. Tepper has taken a quotidian, bourgeois form, one seldom noticed in particular, one designed for convenience and economy, and turned it into an image of damage and instability and at the same time an image of endurance, transformation and perhaps even purity.

It's possible to ascribe his selection of ideas to his times: for instance, his serial study of a standard form relates to Minimalism, and his interest in a common commercial commodity to Pop art, both of which were leading-edge expressions of the '60s, when Tepper was in art school. The contrast of the broken and the ideal also could be seen as relating to the tenor of the '60s, with its student rage and utopian dreams. However, Tepper certainly doesn't fit in any such neat box, as his other works suggest. His unorthodox shifting from industrial design to sculpture, from ceramics to bronze, implies instead a kind of restlessness, even as his degree of fidelity to the cup form seems unprecedented. One is left with respect for his curiosity, his obsessiveness, and the rich implications of the combination of commodity, ideal and damage. His works in bronze, several of which are included in this exhibition, continue and extend this given cup imagery with new interests in patina. Particularly notable are the tiny archeological fragment called ...*But Not Out*, the rim of which hangs in the air like an outline, and *Table Ready*, two tattered cups stacked base to base. All these works embody a range of references and open up to an even larger imaginative realm.

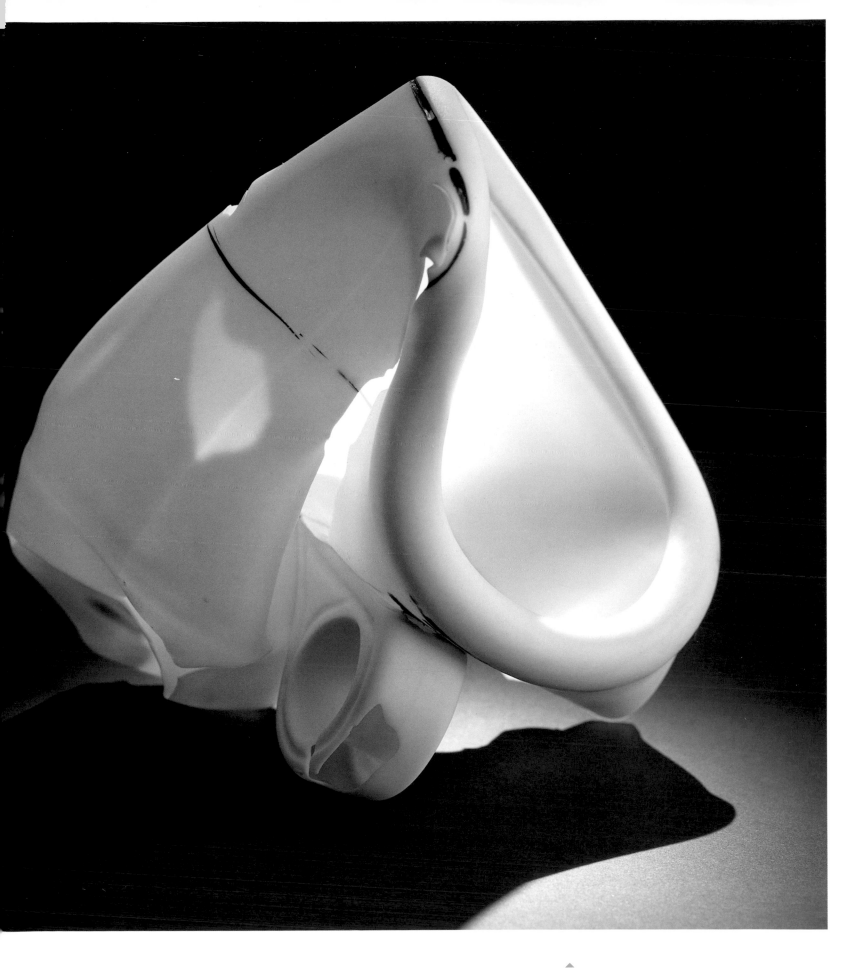

Eva's Enigma, 1998
Porcelain
6 1/4 x 5 x 6"

▶

Cups in Trouble...Perfectly, 2001
Porcelain
6 x 9 3/4 x 13"

▼

**They Don't Know Why They Like
 Each Other,** 1999
Porcelain
14 1/2 x 8 x 8 1/4"

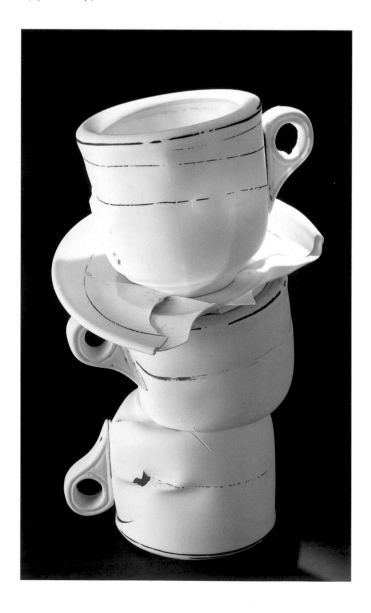

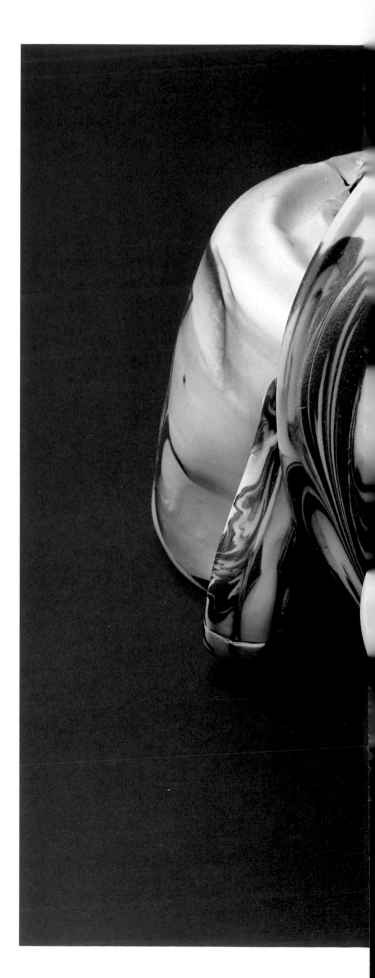

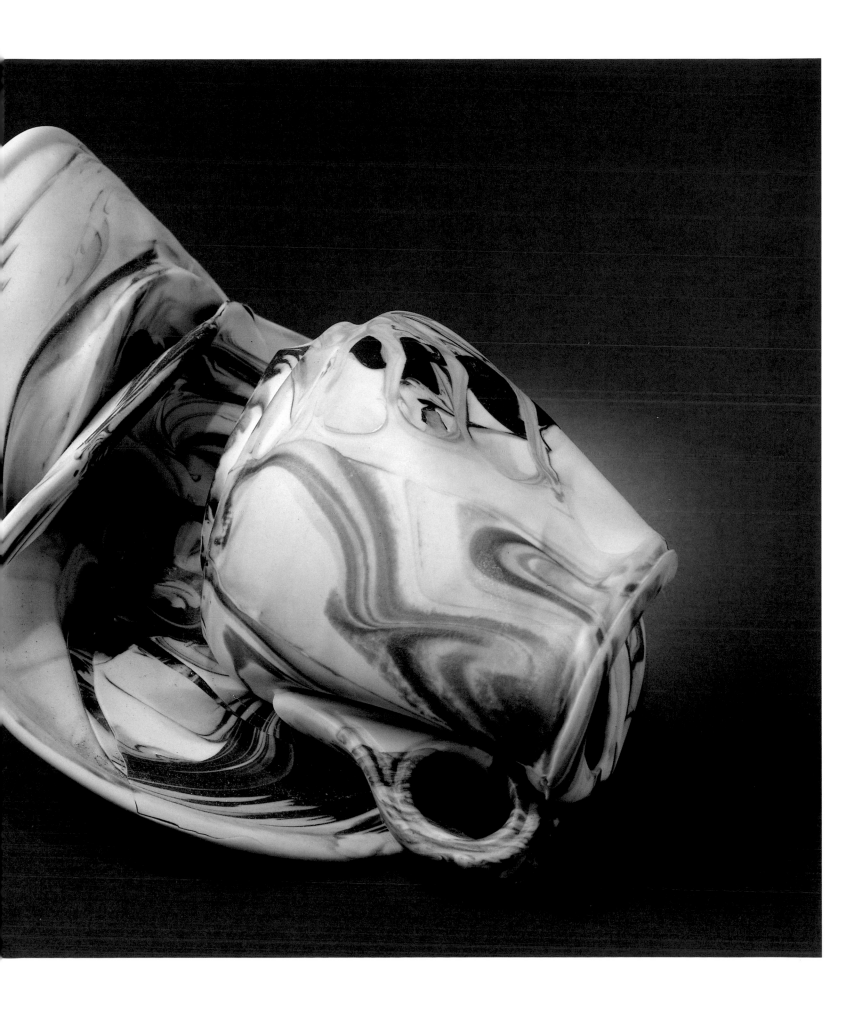

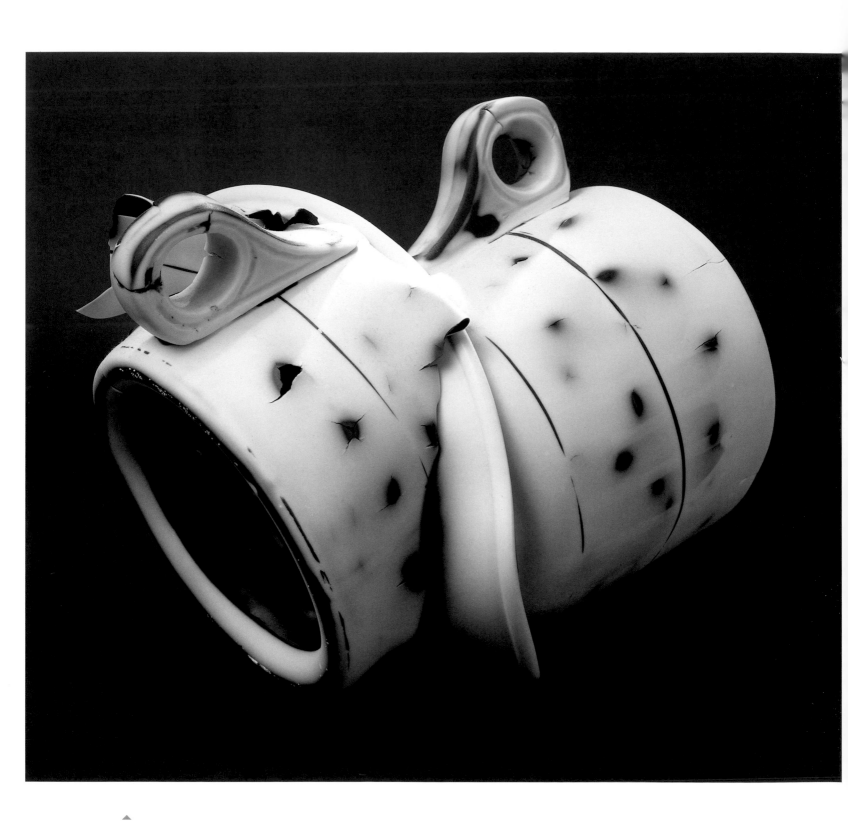

Buddies, *2001*
Porcelain
8 1/4 x 7 1/2 x 8 1/4"

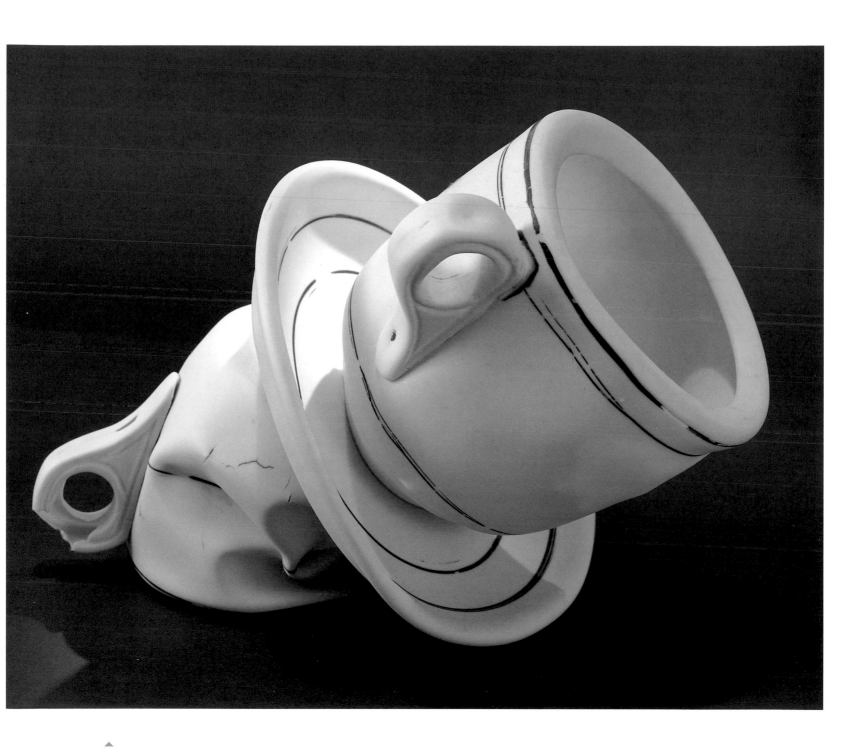

Caught Napping, *1999*
Porcelain
8 1/2 x 12 1/4 x 8"

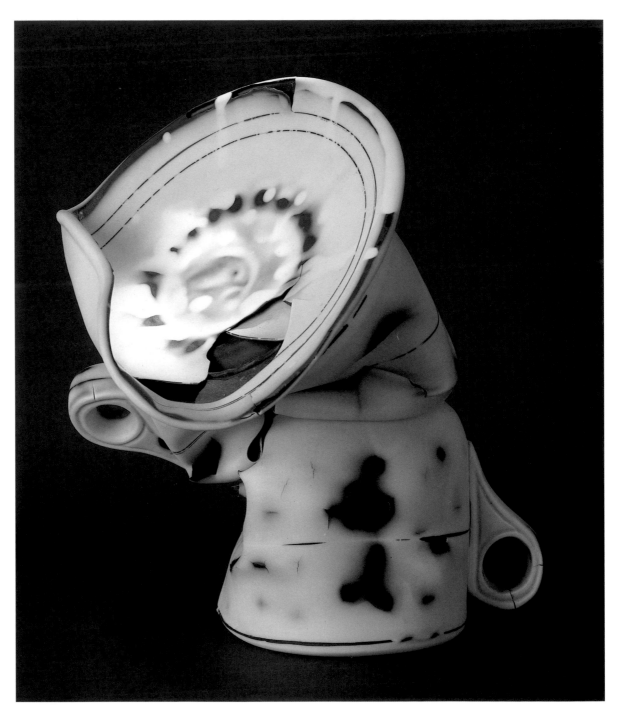

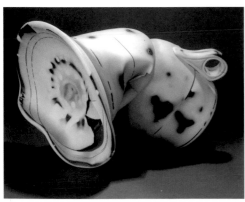

This Earth is Still a Sphere, 1999
Porcelain
10 1/4 x 9 x 9"

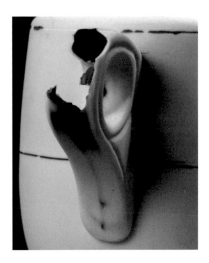

▶
▼

The Boundless One, *1998*
Porcelain
6 x 8 1/2 x 8"

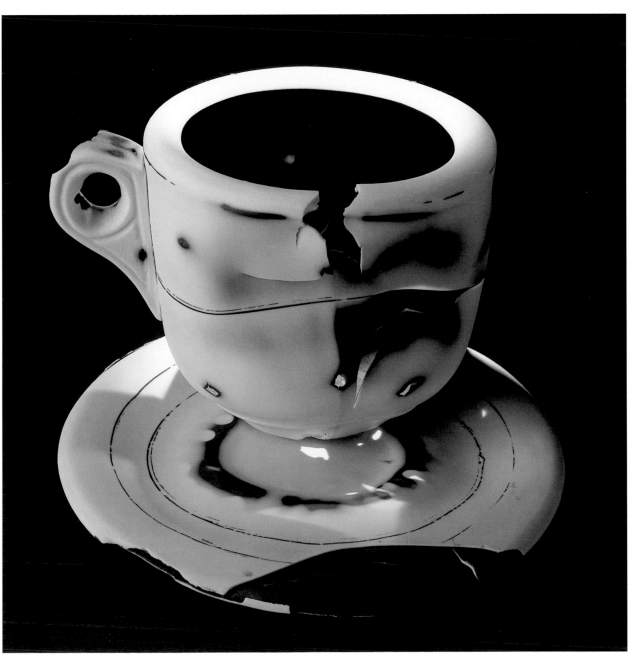

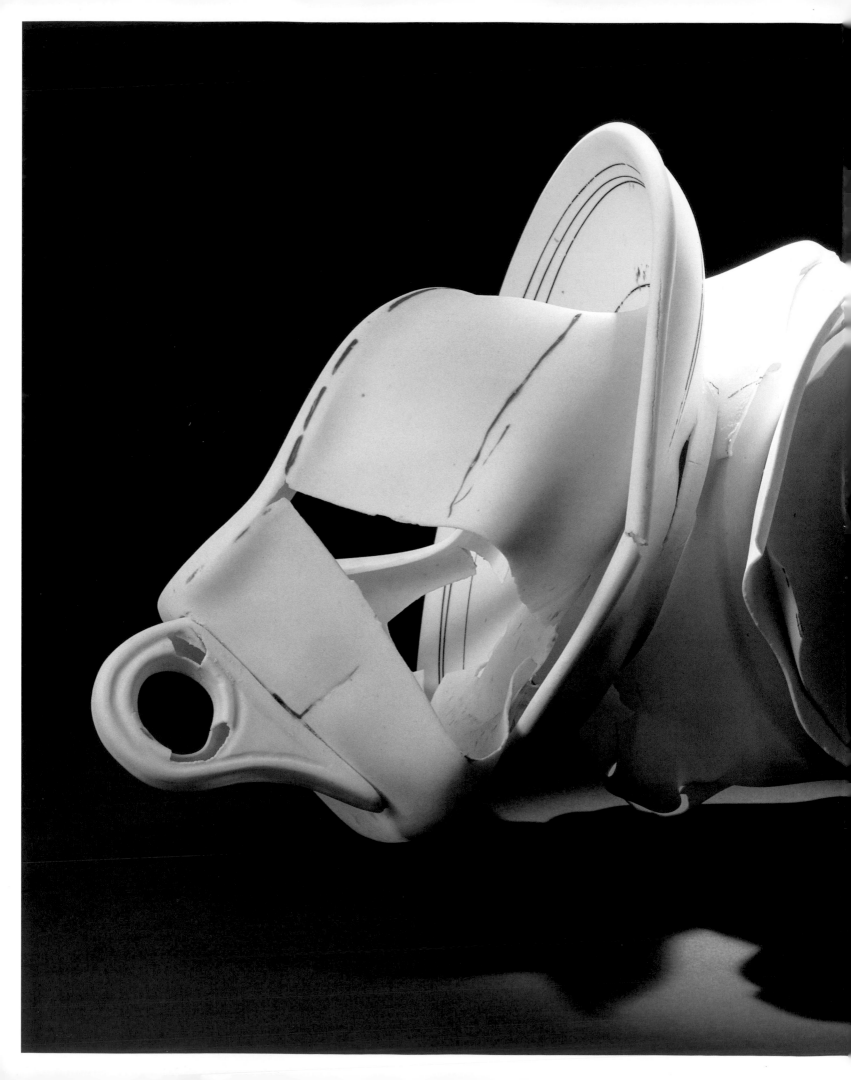

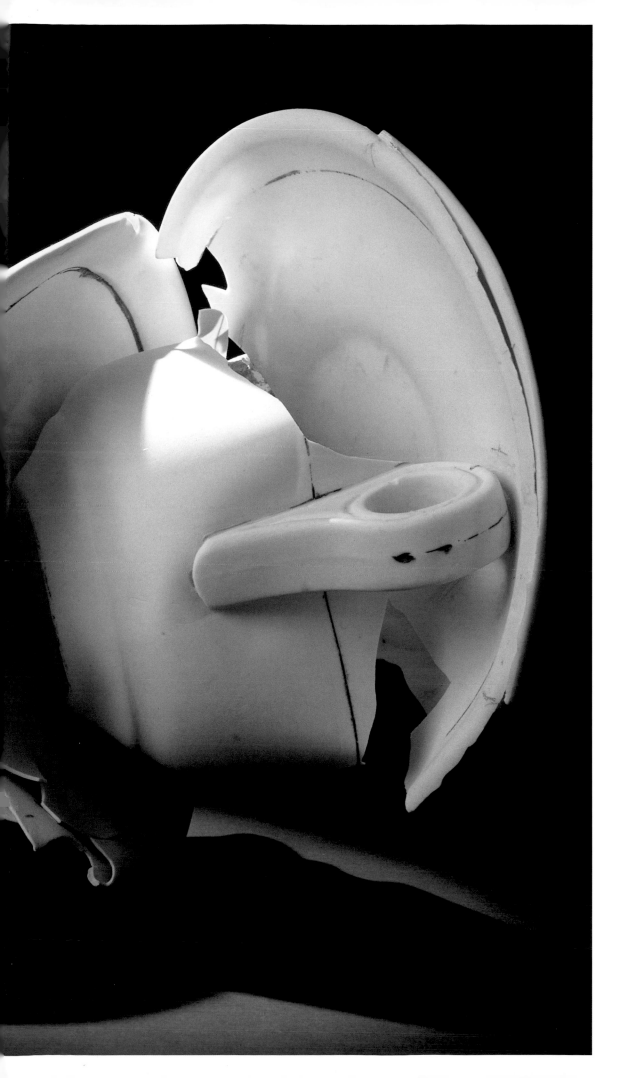

◄

Together Forever, 1999
Porcelain
9 1/2 x 15 1/4 x 9 1/2"

Following Page:
**Selections from Tepper's
Cup Collection,** 2002
*Centre Street Studio Kitchen
New York, NY*

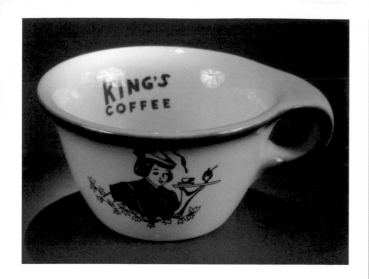

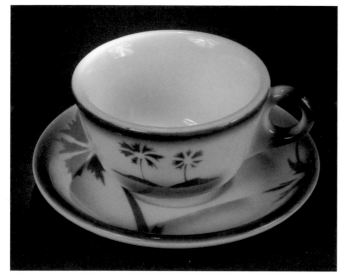

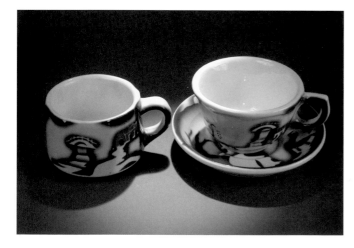

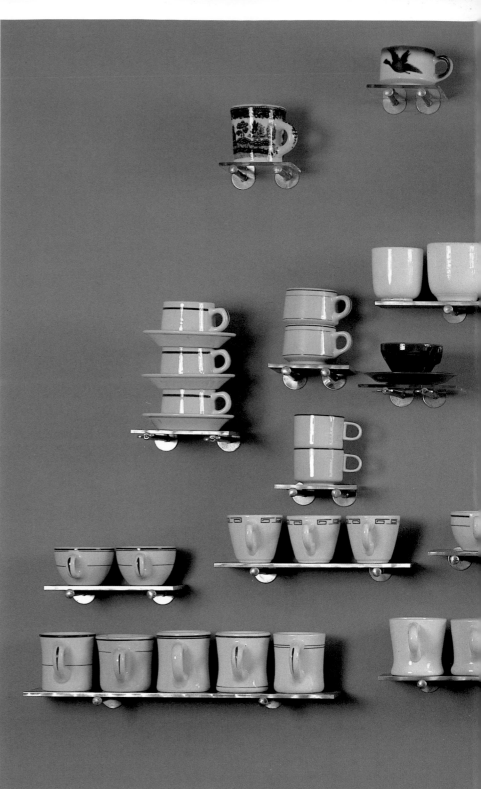

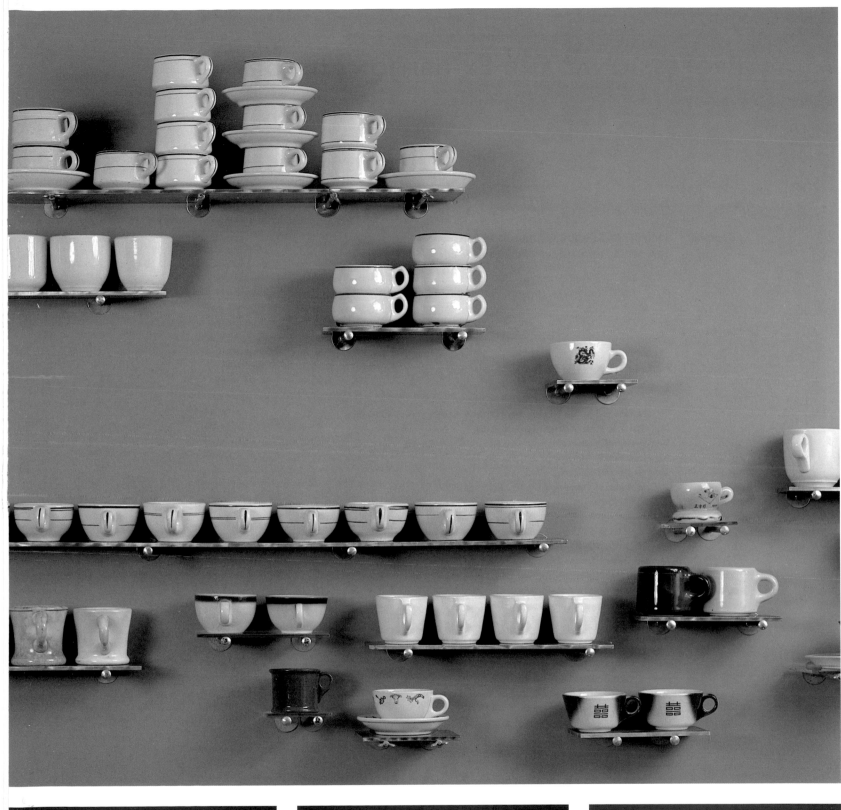
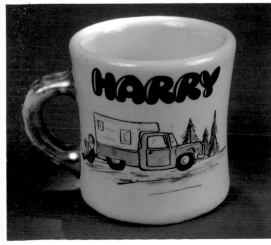
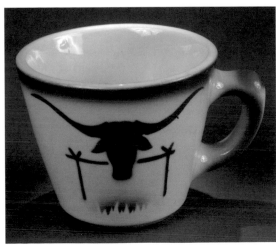

Kruger, George, ed., with Garth Clark and Suzanne Foley. *A Fire for Ceramics: Contemporary Art from the Daniel Jacobs and Derek Mason Collection*. Richmond, VA: Hand Workshop Art Center, 1998, pp. 12–13.

Lauria, Jo, et al. *Color and Fire: Defining Moments in Studio Ceramics 1950–2000*. Los Angeles: Los Angeles County Museum of Art, 2000, p. 227.

Loeffler, Carl E. and Darlene Tong, eds., *Performance Anthology, Source Book for a Decade of California Performance Art*. San Francisco: San Francisco Contemporary Arts Press, 1980, pp. 47, 49, 52, 91, 93, 126, 130, 132, 139, 198, 228, 244, 246.

McKready, Karen. *Contemporary American Ceramics: 20 Artists*. Newport Beach, CA: Newport Harbor Art Museum, 1985, p. 15.

Natsoulas, John. *Second Annual: 30 Ceramic Sculptors*. Davis, CA: Natsoulas Gallery, 1988, p. 21.

Newport Harbor Art Museum. *1984 Annual Report*. Newport Beach, CA, 1984, pp. 5, 9.

Preble, Michael, and Patty Dean. *National Craft Invitational*. Little Rock, AR: The Arkansas Arts Center, 1987, p. 41.

Rena, Nicholas. *Interview With A Cup: Irvin Tepper's Decaffeinated Petaluma*. Unpublished Master's Thesis, Ceramics & Glass Department, Royal College of Art, London, UK, 1994.

Rifkin, Ned. *Stay Tuned*. New York: New Museum, 1981, pp. 22–24.

Schimmel, Paul, Alan Sondheim, and Marc Freidus. *American Narrative/Story Art, 1967–1977*. Houston, TX: Contemporary Arts Museum, 1977.

Schimmel, Paul. *Irv Tepper: Cups, Drawings, Stories*. Newport Beach, CA: Newport Harbor Art Museum, 1983.

Schwartz, Sheila, ed. *Large Drawings and Objects: Structural Foundations of Clarity*. Little Rock, AR: The Arkansas Arts Center, 1996, pp. 60–61.

SITE, CITE, SIGHT. San Francisco: SITE, 1982, p. 68.

Taragin, Davira S. et al. *Contemporary Crafts and the Saxe Collection*. New York: Hudson Hills Press in conjunction with the Toledo Museum of Art, 1993, pp. 130, 207.

SELECTED BIBLIOGRAPHY: ARTICLES AND REVIEWS

"Art in Other Media," *Craft Horizons*. Vol. 30, No. 6 (December 1970), p. 19.

Art/Life. Vol. 16, No. 4 (Issue 169), 1996. Cover.

Art/Life. Vol. 17, No. 4 (Issue 180), 1997.

Blank, Harrod and Jennifer McKay. "The Art Car," *Raw Vision*. Vol. 18 (Spring 1997), pp. 38, 39, 41.

Boettger, Susan. "Made in New York," *Artweek*. Vol. 16, No. 26 (July 27, 1985), p. 5.

Brown, Christopher. "Looking Through Drawing: Irv Tepper, SITE Gallery," *Artweek*. Vol. 10, No. 33 (October 13, 1979), p. 5.

Caruso, L. "Irvin Tepper – Morgan Gallery," *American Ceramics*. Vol. 9 (Spring 1991), p. 51.

Cohen, Ronny H. "Irvin Tepper – Vanderwoude Tananbaum," *ARTNews*. Vol. 83, No. 10 (December 1984), pp. 149–150.

Ewing, Robert. "Metaphors for Experience," *Artweek*. Vol. 14, No. 22 (June 4, 1983), p. 3.

Failing, Patricia. "Northwest Clay Symposium," *American Craft*. Vol. 54, No. 1 (February – March 1994), pp. 38, 43.

Frankenstein, Alfred. "Reconstruction of a Museum: A New Look, New Exhibitions." *This World Magazine, San Francisco Chronicle*. October 15, 1972, p. 38.

Glenn, Constance W. "Collectors: Passion in the Process – The R. Joseph Monsens on the West Coast," *Architectural Digest*. Vol. 40, No. 4 (April 1983), pp. 152–153.

Green, Roger. "Art Exhibit is Contemporary Reaction," *New Orleans State Item*. March 25, 1978, p. 84.

"Happy Boy," *Print Collector's Newsletter*. Vol. 17, No. 2 (May – June 1986), p. 62.

"In Search of the Cutting Edge," *The Studio Potter*. Vol. 12, No. 2 (June 1984), pp. 8, 10–11.

Jenkins, Steven. "Timothy Berry and Irv Tepper," *Artweek*. Vol. 23, No. 1 (January 9, 1992), pp. 13–14.

Juris, Prudence. "Fun and Games at the Institute," *Artweek*. Vol. 3, No. 27 (August 12, 1972), p. 12.

Kansas City Art Institute. *Ceramic Artists: Distinguished Alumni of the Kansas City Art Institute*. Kansas City, MO: Kansas City Art Institute, 1983, pp. 5–6.

Keller, Kathryn. "Irvin Tepper – Documents and Video Tapes," *Artweek*. Vol. 4, No. 40 (November 24, 1973), p. 13.

Kelly, Claire. "West Coast Drawings," *Artweek*. Vol. 8, No. 10 (March 5, 1977), p. 16.

Kent, Tom. "Second Generations," *Artweek*. Vol. 6, No. 6 (March 29, 1975), p. 5.

King, Mary. "Feeling Fantasy in Currents Show," *St. Louis Post Dispatch*. November 23, 1980, p. 5B.

Klein, Ellen Lee. "Irvin Tepper – Vanderwoude Tananbaum," *Arts Magazine*. Vol. 59, No. 4
 (December 1984), pp. 35–36.
Klein, Erica. "Porcelain, Films Speak for Irv Tepper," *The Arts* (St. Louis). Vol. 9, No. 7
 (January 1981), n.p.
Leveton, D. "Irvin Tepper at Morgan Gallery," *New Art Examiner* (Chicago). Vol. 16
 (April 1989), p. 56.
Linhares, Phil. "South of the Slot," *Artweek*. Vol. 6, No. 2 (January 11, 1975), p. 6.
Loeffler, Carl. "Artist as Context," *Data* (Milano). Vol. 27 (July/September 1977), p. 11.
Morris, Gay. "Review of Exhibitions," *Art In America*. Vol. 77, No. 5 (May 1989), pp. 205, 207.
"NEA Crafts Fellowships," *Ceramics Monthly*. Vol. 41, No. 2 (February 1993), pp. 46, 48.
"Prints and Photographs Published: The Big Ear, Big Mouth," *Print Collector's Newsletter*.
 Vol. 15, No. 4 (September/October 1984), p. 145.
"Prisoner – Silver Point," *ZYZZYVA*. Vol. 2, No. 2 (Issue #6, Summer 1986), p. 141.
Pugliese, Joseph. "The Decade: Ceramics," *Craft Horizons*. Vol. 33, No. 1 (February 1973), pp. 46–53.
Ratcliff, Carter. "Report from San Francisco," *Art in America*. Vol. 65, No. 3 (May/June 1977), p. 58.
Schimmel, Paul. "Conversation Pieces: The Cups of Irvin Tepper," *American Ceramics*.
 Vol. 3, No. 2 (March 3, 1984). Cover, pp. 30–39.
Schipper, Merle. "Narratives in Words and Images," *Artweek*. Vol 9, No. 7
 (February 18, 1978), p. 16.
Skratz, G.P. "Together Again for the First Time: The Farm," *Artweek*. Vol. 10, No. 30
 (September 22, 1979), p. 4.
Spanner/NYC (New York), "Green" Issue, 1979, pp. 42–43.
Stricker, Ursula. *Berner Zeitung* (Bern, Switzerland). July 6, 1982, n.p.
Upshaw, Reagan. "Irvin Tepper at Vanderwoude/Tananbaum," *Art in America*. Vol. 72, No. 11
 (December 1984), p. 172.
Van Proyen, Mark. "Synthesis and Fracture." *Artweek*. Vol. 16, No. 44 (December 28, 1985), p. 7.
Von Ziegesar, Peter. "Report from Kansas City: Art in the Heartland," *Art In America*. Vol. 83,
 No. 6 (June 1995), p. 53.

TEACHING EXPERIENCE:

1997–present	Pratt Institute, New York, NY; Graduate Program, Fine Arts and Industrial Design
1995	Rhode Island School of Design, Providence, RI; Sculpture
1995	Anderson Ranch Arts Center, Snowmass Village, CO; Sculpture
1991–1994	San Francisco Art Institute, San Francisco, CA; Interdisciplinary Studies and Sculpture
1989	San Francisco Art Institute; Sculpture
1989	Kansas City Art Institute, Kansas City, MO; Visiting Artist, Foundation Program
1989	Anderson Ranch Arts Center; Drawing
1987–89	University of California, Berkeley, CA; Sculpture, Video and Performance
1987–88	San Francisco Art Institute; Ceramics and Figure Molding With Clay
1986	Anderson Ranch Arts Center; Ceramics
1985	San Francisco Art Institute; Drawing
1984	Maryland Art Institute, Baltimore, MD; Visiting Artist, Seminar
1982	New York University, New York, NY; Ceramics
1977	California College of Arts and Crafts, Oakland, CA; Advanced Photography
1972–79	University of Santa Clara, Santa Clara, CA; Photography, Ceramics, Sculpture
1971–72	California State University, Hayward, CA; Printmaking and Ceramics
1969–71	University of Washington, Seattle, WA; Teaching Assistant; Ceramics
1969	Kansas City Art Institute; Ceramics

PRIZES AND AWARDS:

The Orange Show/Houston Arts Festival, Houston, TX. Honorable Mention – Photography, 1996
Djerassi Foundation, Woodside, CA. Agnes Bourne Fellowship Award, 1989
National Endowment For The Arts, Washington, DC. Visual Arts Program – Crafts,
 Individual Artist's Fellowship, 1992
San Francisco Arts Festival, San Francisco, CA. Video Prize, 1978

LENDERS TO THE EXHIBITION

Marcie McGahey Cecil, La Jolla, CA

Kenneth A. Cowin, New York, NY

Dan and Jeanne Fauci, Los Angeles, CA

Geanne Finney, New York, NY

Jim Friedman and Suzanne Stassevitch, San Francisco, CA

Katie and Drew Gibson, Pebble Beach, CA

Ben Liberty, New York, NY

John Martin and David Turner, San Mateo, CA

Museum of Contemporary Art, Los Angeles, CA

Orange County Museum of Art, Newport Beach, CA

Joseph L. Parker, Jr., Tulsa, OK

Private Collection, Berkeley, CA

Private Collection, CA

Dotty and Arnold Tepper, St. Louis, MO

Irvin Tepper, New York, NY